HIDDEN

HISTORY

of

MIDDLESEX

COUNTY,

CONNECTICUT

HIDDEN
HISTORY
of
MIDDLESEX
COUNTY,
CONNECTICUT

Robert Hubbard, Kathleen Hubbard
and the Middlesex County Historical Society

THE
History
PRESS

Published by The History Press
Charleston, SC
www.historypress.com

Front cover: Cowboy Valley in Killingworth, Connecticut, circa 1958. *From the archives of the Killingworth Historical Society.*

First published 2018

Manufactured in the United States

ISBN 9781467139274

Library of Congress Control Number: 2018932100

CONTENTS

CONTENTS

Acknowledgements

One of the reasons that we chose to write another book with the Middlesex County Historical Society was that we would work again with its executive director, attorney Deborah Shapiro. Few people are as knowledgeable of Connecticut history as Debby or do as much to preserve and educate the public on local history. In 2017, the American Association for State and Local History gave two awards to the Middlesex County Historical Society for its current exhibit, "A Vanished Port: Middletown & the Caribbean, 1750–1824." Debby's innovative leadership makes such projects possible.

In collecting photographs for this book, we had a good start—the son of one of the county's most distinguished residents, Academy Award winner Art Carney, provided us with pictures of his late father and their Westbrook home. Our thanks go to Brian Carney.

It has been our honor to interview Harry Ruppenecker about his role in the rescue of three boys in Long Island Sound almost fifty years ago. Mr. Ruppenecker is an inspiration to us, and we are sure his story will inspire our readers.

It was our pleasure to interview Harold and Theodora Niver, who have not only entertained and educated tourists for forty years at Gillette Castle but are also living repositories of information on William Gillette and his unique home.

Our gratitude goes to all those who shared their stories with us. We acknowledge Bion Shepard, who told us of Hugh Lofting reading his Dr.

Dolittle stories to his elementary school class in the 1940s. Dan Perkins and Marty Machold provided us with details of their experiences at Killingworth's Cowboy Valley in the 1950s, and Richard Murphy gave us one-of-a-kind information on Portland's Jobs Pond in the 1960s.

Others we are indebted to include Diane Lindsay, curator, Chester Historical Society (Thanks for the photographs!); Tom Marshall, an expert on Silliman products; Dr. Lucianne Lavin, American Cultural Specialists; Peter Zanardi and Ed Wilcox, both authorities on Middlesex County sports; and Eileen Sottile Angelini and Paul Angelini, the owners of James Pharmacy (Thanks Eileen for your generous time in sharing your passion of the legacy of Miss James and for keeping her spirit alive while completing your renovations).

We also thank Wangunk family historian Gary O'Neil for providing valuable information; Melissa Josefiak, director of the Essex Historical Society, for her help with the "Clinton grave marker"; Marta Daniels for information on Judge Constance Baker Motley; Joel Severance for his knowledge of local history; Tom Comer for information on his great-grandfather Captain George Comer; and Dr. Karl Stofko for his encyclopedic knowledge of East Haddam history.

We are grateful to Susan Ryczek of the Middlesex County Historical Society for her expert copyediting of our final manuscript. We appreciate Phil Pessoni, who not only assisted us with our *Legendary Locals of Middletown* book but once again generously gave of his time to discuss Westbrook history.

Sometimes in the writing of local history, it's necessary to obtain information that cannot conveniently be found except by consulting world-renowned scholars. Among those that aided us for this book were Dr. William Johnston, professor of history, Wesleyan University; and Stefan Nicolescu, collections manager, Division of Mineralogy and Meteorites, Peabody Museum of Natural History, Yale University.

We wish also to thank Killingworth Municipal historian Dr. Thomas Lentz; Cathie Neidlinger Doane, president, Westbrook Historical Society; Bill Konefal, president, Middlefield Historical Society; Skip Hubbard (no relation to the authors), president, Chester Historical Society; Ray Hubbard (also no relation); Arlene Sakatos and Maddie Bradley at the Old Saybrook Historical Society; President David Bautz, librarian Charlotte Neely and member Scott Renfrew of the Clinton Historical Society; and Deep River Historical Society's Rhonda Forristall, whose book on Billy Winters will be released in 2018. Also, we thank George Dupree for access to his excellent collection of postcards.

As always with our books, librarians helped us greatly. Hoping we do not leave anyone out, we'd like to mention Tammy Eustis, head librarian, Killingworth Library; Laurie Prichard, assistant director, East Haddam Library System; and Denise Russo and her wonderful staff at the reference department of Middletown's Russell Library. Librarians at the public libraries in Deep River, Old Saybrook and Portland were also especially gracious and helpful.

Thanks also to attorney Paul Buhl; Nancy Thurrott; Orion Horton Henderson, president of Horton Brasses Inc.; and Richard Kalapas, Deep River town historian.

We wish to thank Michael G. Kinsella at The History Press for his work on this project. It's always a pleasure to work with someone who is as experienced and knowledgeable as Mike. We also thank editor Abigail Fleming for her valuable suggestions and careful review of the text.

Finally, we acknowledge the other people who assisted us informally with this book. They deserve recognition for freely giving of their knowledge of their communities and sharing directions to local "hidden" sites. We thank the docents who volunteered their time, those who gave us "backdoor tours" and anyone else that we should have mentioned. Thanks for your generosity in sharing your passion and expertise.

INTRODUCTION

The one timeless element that links the towns and villages of Middlesex County together—and provides the most obvious sign of its identity—is the Connecticut River. Ten of the county's fifteen towns touch the river, and two additional towns, Middlefield and Westbrook, used to be part of the river towns of Middletown and Deep River. Only Durham, Killingworth and Killingworth's offspring Clinton never had Connecticut River frontage.

The four-hundred-mile-long Connecticut River stretches south from the Canadian border, winds between New Hampshire and Vermont, makes a beeline through Massachusetts and completes its journey to the ocean in Connecticut. Seventy percent of Long Island Sound's fresh water comes from the Connecticut River. However, the only section navigable by large ships is the southern portion—the part that is entirely in Middlesex County. Significantly, the river's 1795 custom house was not located on Long Island Sound but rather thirty miles upriver in Middletown.

The river has changed over the centuries. Ferry barges operated by oxen and horses were replaced by motorized vehicles, oceangoing sailing ships were supplanted by steamboats and ultimately, pleasure craft and tour boats inherited the waters.

In the days of Native American fishing and in the early years of English settlement, shad and salmon were abundant in the Connecticut River. They were such inexpensive food that indentured servitude agreements often specified the maximum number of times an apprentice could be fed salmon.

Both along the river and inland, farmers reaped the benefits of rich soil to grow corn, potatoes and other crops. Even the inland communities of Durham and northern Killingworth relied on the Connecticut River to transport much of their produce and to receive in return needed commodities such as sugar, rum and cotton.

Middlesex County was created in 1785 from parts of Hartford County and New London County. Middletown, Chatham, Haddam and East Haddam came from Hartford County, and Saybrook and Killingworth were taken from New London County. Fourteen years later, Durham was taken from New Haven County.

In later years, some towns spun off as new municipalities: Middletown spawned Cromwell in 1851 and Middlefield in 1866; Chatham became East Hampton and Portland; Clinton split from Killingworth in 1838; and Saybrook broke up into Saybrook, Chester (1836), Westbrook (1840), Essex (1852) and Old Saybrook (1854). In 1947, the Connecticut legislature changed the name of Saybrook to Deep River.

The county was named for Middlesex County, England, which today is part of Greater London. The average length of Connecticut's Middlesex County from north to south is twenty-seven miles and the average width, east to west, is fourteen miles. In 1960, the State of Connecticut abolished county government for all of its eight counties, and today, the only remaining county government body is the Middlesex County Judicial District.

The early twenty-first-century population of Middlesex County towns ranges from Middletown with approximately forty-eight thousand people to Chester with four thousand. The average town has about eleven thousand residents. Several of the county towns are broken up into villages, with Essex containing Essex Village, Centerbrook and Ivoryton; Haddam, consisting of Haddam Neck, Higganum and Haddam Village; East Haddam containing Moodus, Millington and Leesville; Middlefield, including Rockfall; East Hampton, including the village of Lake Pocotopaug; and Old Saybrook comprising Old Saybrook Center, Saybrook Manor and the Borough of Fenwick.

The most valuable county land for agriculture was always considered that of the shore towns of Clinton, Westbrook and Old Saybrook and, north of them, the towns of Middletown, Middlefield, Cromwell, Durham and Portland. The most successful crops included corn, oats, wheat, rye, potatoes, onions, tobacco and fruit. Grass for raising cattle, sheep, goats and so forth was abundant.

The late eighteenth century brought industry to the county, and the Industrial Revolution of the 1800s accelerated the construction of factories. This led to people moving from farms to industrial areas, as well as the addition to the labor force of workers from southern states and immigrants.

Much of the county's manufacturing suffered in the post–World War II years as companies moved their facilities to locations with less expensive labor—especially to the southeastern United States or to other countries. Partly filling the void were information-centered positions, service jobs and jobs related to the tourist industry.

THE RIVER VALLEY

Dinosaurs, Bizarre Noises and a Bottomless Lake

F or thousands of years, Native Americans lived, hunted and fished on the land now comprising Middlesex County. Millions of years before them, dinosaurs walked the land. Today, there are more dinosaur tracks found in the Connecticut Valley than in any other place on earth. Middlesex County has two major track locations: in the Portland brownstone quarries and in a ledge near Middlefield's Lake Beseck.

DINOSAUR TRACKS

In 1866, the Connecticut legislature split off a thirteen-square-mile western section of Middletown, creating the town of Middlefield, which is the last town to be added to Middlesex County. However, Middlefield's story began long before then—200 million years before, in the early Jurassic period. Dinosaurs walking through river mud left imprints of their feet, which are still visible today.

Hidden away on a ridge near Lyman Orchards is the tiny Powder Hill Dinosaur Park where the three-toed Eubrontes giganteus, Anchisauripus and Grallator once roamed. Their tracks embedded in the brownstone range from less than fifteen centimeters to about twenty-five centimeters long. Landowner Wesley Coe discovered the track site in 1846 when stone was quarried there for the Lake Beseck Dam. He later became a professor

Two of the dinosaur tracks on display at the Portland Public Library in Portland, Connecticut. *Authors' collection.*

at Yale University in New Haven, and after his death, his family donated the property to Yale's Peabody Museum.

In 1976, the museum deeded the site to Middlefield. For many decades, the little park delighted hundreds of children each year. That almost came to an end in a recent year when someone broke off large slabs of stone with some of the clearest tracks and loaded them into a car. Fortunately, an alert neighbor witnessed it and contacted the authorities, who were able to recover the tracks.

In the nineteenth and twentieth centuries, countless dinosaur tracks were found in the brownstone quarries of Portland, Connecticut. Because their shape resembled bird feet, many people believed they were made by giant birds. A few of the tracks were saved by construction crews. In 1874, a sixty-foot-long pattern of tracks was unearthed in Portland, and today it is on display at the Hartford Public Library. Other Portland quarry tracks, which presumably belonged to an Anchisauripus and an Otozoum, are mounted on the walls of the Portland Public Library.

WADSWORTH FALLS

Sometimes described as a "miniature Niagara Falls," Wadsworth Falls on the Coginchaug River has always been Rockfall's main natural attraction. Beginning in the 1700s, it was the location of a gristmill, a sawmill, a cotton factory and a spinning mill, successively. Since 1942, the waterfall has been part of the 267-acre Wadsworth Falls State Park. The park, which stretches

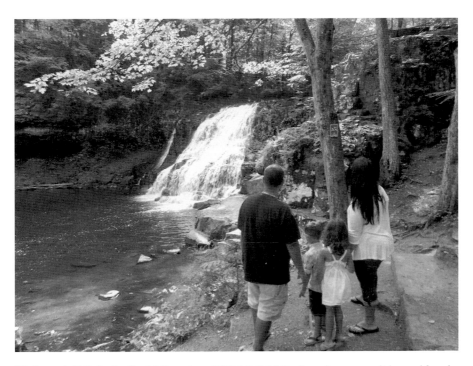

Wadsworth Falls in the Rockfall section of Middlefield. In the rainy season, it is considered the fifth-most powerful waterfall in Connecticut. *Authors' collection.*

from Middletown to Middlefield, owes its existence to a land grant from wealthy Middletown resident Clarence Wadsworth.

As many as eight hundred gallons of water per second flow over the Wadsworth Falls, making it the fifth-most powerful waterfall in Connecticut. A Middlefield history from 1884 described Wadsworth as falling "35 feet, and when the stream is full roar is heard for several miles."

MOODUS NOISES

Native Americans called this area of East Haddam *Machimoodus*, which means "the place of noises." Throughout recorded history, strange noises have emanated from a spot near Mount Tom.

In 1729, Reverend Stephen Hosmer wrote of the noises: "Earthquakes have…been observed for more than thirty years…sounds and tremors, which sometimes are very fearful and dreadful.…I have, I suppose, heard

Mount Tom in Moodus, which is one of the most common locations of the Moodus noises. *Authors' collection.*

several hundred of them within twenty years." In the 1830s, the sounds were described as varying between "the roar of a cannon and the noise of a pistol."

One of the worst episodes of the noises in Moodus occurred on the evening of May 18, 1791, when the area was shaken by an earthquake that knocked down walls and the tops of chimneys. Two shocks were felt as far away as New York and Boston, while twenty to thirty shocks were experienced locally. It created cracks in the earth and moved large boulders.

Today, residents and visitors still hear the sounds, and the local Nathan Hale–Ray High School's sports teams are called the Noises.

MYSTERY LAKE

Portland is home to a thirty-six-acre pond so unusual it's often called "Mystery Lake." With the official name Jobs Pond, the turkey drumstick–shaped body of water sits northeast of Route 66 and has no visible outlet.

For as long as anyone can remember, its water level fluctuates for no apparent reason. In the dry season, it might be higher than normal, while in a rainy spring, it might be unusually low.

Former Jobs Pond resident Richard Murphy remembers the fluctuating pond well. He recalls that he and his friends were able to walk across the pond, while at other times "you had water in your house." He had heard that the pond was about ninety to one hundred feet deep in the deepest part and was spring fed. In the sixteen years he lived on its shore, it seemed to him that the pond followed a cycle of seven or eight years at high water level and seven or eight years at low level.

In 1984, the water level was so high that state and federal authorities considered a plan to pump 100 million gallons of water from Jobs Pond to the Connecticut River, one mile away. Referring to Jobs Pond and its baffling water level fluctuations, a chief engineer with the Connecticut Department of Environmental Protection at the time told a *Hartford Courant* reporter, "I can guarantee you there isn't another one like it in Connecticut."

Jobs Pond, also known as Mystery Lake, in Portland. The pond's fluctuating water level has baffled local residents and visitors for decades. *Authors' collection.*

People have conjectured that an underground river is causing the water level fluctuations. There is indeed such a river; however, it has been dry throughout recorded history. Others have insisted that the pond is bottomless, but scientists have frowned at that possibility. Instead, they propose that Jobs Pond is a kettle. During the last ice age, glaciers receded through what is now southern New England. About one mile in depth over Connecticut, these glaciers dropped sand, gravel and blocks of ice as they left. Some of the ice became partially or completely buried in sediment before melting, forming depressions in the surface called kettles. If they filled with water, they became ponds and lakes, often below the water table. Scientists have determined that the water level of Jobs Pond is directly related to the area's groundwater level. When it is high, the sand at the pond's bottom fills with water and the pond's surface level rises.

Murphy noted that the pond seems to be losing its signature variability over the last fifteen years. This is probably due to sediments flowing into it from new road construction on its northwest side and work on Route 66 on its south side.

THE ISLANDS

Some of Middlesex County's hidden treasures are the islands that populate the Connecticut River, Long Island Sound and East Hampton's Pocotopaug Lake.

There are over 130 islands off Connecticut's Long Island shore. Three of the main ones are Westbrook's barrier islands: Salt, Duck and Menunketesuck Islands, which are owned by the Town of Westbrook, the State of Connecticut and the federal government, respectively.

Salt Island, with its deep-water harbor, has always been the most developed of the three Westbrook islands. Sailing ships would stop here and, at low tide, transport their cargos of lumber, fruits and vegetables to and from the mainland. In the late 1880s, it was also the location of the Salt Island Oil Company, which processed menhaden oil and fish guano. The business folded when complaints about its smell became overwhelming. Today a property of the Town of Westbrook, Salt Island is known as a bird nesting ground.

Lying a mile south of the Grove Beach section of Westbrook, 5.6-acre Duck Island is best known as the location of a hospital where Westbrook's Dr.

John Ely gave smallpox inoculations in the 1770s. One of the most famous physicians of the American Revolution, Colonel Ely (1737–1800) was held in great esteem by General Washington for his work to stop smallpox from decimating the Continental army and for his efforts, while a prisoner of the British, to give his fellow prisoners medical care. He refused to be exchanged and remained a prisoner for over three years because he didn't want to leave the sick prisoners who depended on him.

The British burned Ely's hospital on Duck Island during the Revolutionary War. A century later, the U.S. Army Corps of Engineers constructed two breakwaters that provided safe anchorage for vessels traveling between New London and New Haven. After the State of Connecticut purchased Duck Island in 1973, it established a major egret rookery.

Menunketesuck Island, sitting just northeast of Duck Island, is named after a local branch of the Nehantic tribe. It is said that in 1893, pirates established a camp on the island from which they would sneak over to the mainland at low tide and steal from beachfront residents. At high tide, they would return to Menunketesuck. Today, the fifteen-acre island is part of the Stewart B. McKinney Wildlife Sanctuary.

Seven of Middlesex County's islands lie in its portion of the Connecticut River: Lord and Rich Islands off East Haddam's shore, Brockway Island and Thatchbed Island off Essex, Haddam Island off Haddam's shore, Gildersleeve Island off Portland and Wilcox Island, which is jointly owned by Middletown, Portland and Cromwell.

Haddam Island was also known as Thirty Mile Island since it was incorrectly estimated in the seventeenth century to be 30 miles from the mouth of the river. (It's actually only seventeen miles away.) In 1662, when the Wangunks sold Haddam to English settlers, they retained this island for themselves.

As the native population disappeared, the island became a center for commercial fishing. The construction of the Haddam Island's piers began in winter, as large stones were pulled by oxen across the iced-up river. When the ice melted in the spring, the stones would drop, forming foundations.

In the 1800s, two fishing companies operated off Haddam Island, and farmers used the land for grazing cattle. It was common practice for thrifty and practical New Englanders to use islands this way, as there was no danger of the livestock wandering away.

Today, Haddam Island's fourteen acres are the location of Haddam Island State Park, a favorite of bird-watchers and boaters. It was one of the places in Connecticut where one of the most famous pirates in history, Scottish-

born Captain William Kidd (1654–1701), might have buried treasure. Apparently, no one ever reported finding it. The nearby town of Chester is another rumored Kidd treasure site location.

Three-square-mile Pocotopaug Lake in East Hampton is home to the county's largest inland islands: Scraggy Island and the Twin Islands. Throughout the 1800s, residential cottages and tourist facilities lined the lake's shore, while factories utilized waterpower from the lake.

EARLY MIDDLESEX COUNTY

*Native American Settlements, Washington's Trail
and the Invasion of America*

WANGUNKS

The Wangunks were an Eastern Algonquin Native American people who lived in areas now occupied by the city of Middletown and the Middlesex County towns of Middlefield, Cromwell, Portland, East Hampton, Durham, Haddam and East Haddam as well as the non–Middlesex County towns of Glastonbury and Wethersfield. Their main settlement was on the east side of the Connecticut River near where the river bends at Middletown. In fact, the name *Wangunk* means "the people at the bend in the river."

After Europeans began settling the area in the 1600s, both they and the warlike Pequot people vied with the more peaceful Wangunks for the land of the lower Connecticut River that was rich in fur-bearing animals. In the mid-1600s, the Wangunk leader Sowheage allied with the Narragansett tribe against the Pequots. After the defeat of the Pequots by the English in the Pequot War, Wangunks and Narragansetts fought the Mohegans. In the 1700s, a small band of Wangunks was living in a section of Portland called Wangunk Meadows. Wangunk family historian Gary O'Neil explained to the authors, "To be an enduring people in that situation was extremely difficult, but we have had meetings and gatherings through the decades."

Although small in numbers, the Wangunks have contributed much to the county and the state. Oliver Palmer, for example, gave his life in the

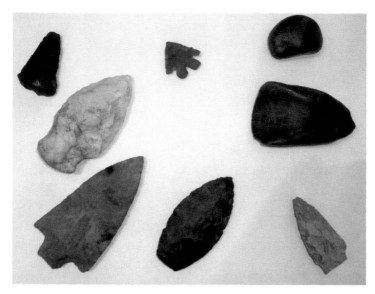

Native American arrowheads and other artifacts found in the southern section of Middletown. *Middlesex County Historical Society Collection.*

The town of Haddam occupies land on both sides of the Connecticut River. Haddam Island, also known as Thirty Mile Island, sits between the two Haddam shores. *Authors' collection.*

Civil War. O'Neil recounted, "Our people were willing to serve in every war even though they did not have equal rights as Americans." In the twenty-first century, there are over six hundred living people who can trace their ancestry to the Wangunks.

PEST HOUSES

In the colonial period, severe illness was a constant worry. Smallpox killed three out of every ten people it infected. Caused by the variola virus, it quickly spread from one person to another. Its symptoms included a fever and a distinctive skin rash, which often left permanent scarring.

In the seventeenth and eighteenth centuries, Middlesex County experienced a number of serious epidemics, with the most notable being the smallpox outbreaks. Although everyone was in danger, the county's Native American population, which had no natural immunity to the diseases, was especially vulnerable.

Today, several vestiges of smallpox epidemics survive in Middlesex County. The ruins of one home/hospital for people infected with smallpox lies in the Meshomasic State Forest in Portland. Another pest house, as it was called, is in a remote corner of Durham.

In 1760, Durham's town government bought one and a half acres and built a twenty- by thirty-foot house. For thirty years, residents who contracted the disease were forced to live there (and be buried there). Their isolation limited outbreaks, but their separation and segregation from family and the community caused loneliness and anguish.

Located northwest of Pisgah Mountain, the remains of Durham's pest house consist of the building's foundation, as well as about thirty now unmarked graves. At least one man had two grave markers—one over an empty tomb in the main cemetery on Durham's Main Street and the other over his actual grave at the pest house.

Other county towns with smallpox cemeteries include Westbrook and Old Saybrook. In 2000, Connecticut state archaeologist Nicholas Bellantoni stated, "I'd bet that every town of colonial antiquity has one."

In the late 1700s, some doctors (including ones in Middletown, Haddam and Old Saybrook) would perform primitive smallpox inoculations on people. The patients would usually suffer for a few weeks with a milder form of the disease and end up with immunity.

As a result of systematic modern vaccination programs, smallpox was wiped off the earth in the twentieth century. The last person to die of naturally occurring smallpox passed in 1977, and the last person to die of it as a result of exposure at a research laboratory died in 1978. In 1980, the World Health Assembly declared smallpox to be eradicated.

MILITARY ENGAGEMENTS

From the time when Native American tribes battled one another for territory until present-day wars, residents of the area today known as Middlesex County have volunteered for military service. Every town in the county has memorials to the sacrifices of men and women who have defended their families, their towns, their state and their nation.

Middlesex County's greatest military figures include Revolutionary War leaders Major General Joseph Spencer from East Haddam, General James Wadsworth of Durham and Colonel Return Jonathan Meigs of Middletown. Thomas Macdonough Jr. was the commander of American naval forces at the War of 1812's Battle of Lake Champlain, and Union army major general Joseph K.F. Mansfield was mortally wounded at the Civil War's Battle of Antietam. Middletown-born Major General Maurice Rose was the highest-ranking American killed by enemy fire in Europe in World War II.

OLD SAYBROOK

The original natives of today's Old Saybrook were the peaceful Algonquin Nehantic Indians who, in the late seventeenth century, were conquered by the warlike Pequot tribe.

In 1614, a Dutch expedition under Adrian Block represented the first Europeans to venture up the Connecticut River. While the Dutch traded such items as knives and coats to the local people in exchange for furs, they failed to establish a permanent colony in the area.

The English colony of Saybrooke at the mouth of the Connecticut River was settled in 1635, making it the oldest town on the Connecticut shoreline. The following year, under orders from the colony's first governor, John Winthrop Jr., Lieutenant Lion Gardiner built a fort

on Saybrook Point to deter occupation by Dutch settlers and fend off Indian attacks. It was Connecticut Colony's first fort. That same year (1636), Lieutenant Gardiner's son was born at the fort, becoming the first European to be born in Connecticut. After several years as commander at Fort Saybrook, Lion Gardiner bought a five-square-mile island in Long Island Sound. For over three centuries, Gardiners Island has been owned by his descendants.

In the first years of the fort, the colony's leaders, allied with Chief Uncas and his Mohegan tribe, fought and defeated the Pequots. Today, Fort Saybrook Monument Park in Old Saybrook sits on some of the ruins of the original fort. However, much of the fort and its earthwork fortifications were destroyed in the late nineteenth century when the railroad constructed a roundhouse (a circular building in which locomotives were stored and serviced) on the site.

The settlement was named for Viscount Saye and Sele and Lord Brooke, who received a patent from the British Earl of Warwick for a vast tract of land stretching from southern New England to the Pacific Ocean. Today, the central location of that settlement is in the town of Old Saybrook.

Over the years, six towns split off from Saybrook—the Middlesex County towns of Westbrook, Chester, Deep River and Essex, and New London County's Lyme and Old Lyme. Today, Old Saybrook is the only town in Middlesex County to border both the Connecticut River and Long Island Sound.

Joseph Spencer

Joseph Spencer was born in East Haddam's Millington village in 1714. One of Middlesex County's most able military leaders, he served during the French and Indian War as a major in the second Connecticut Regiment and later as a colonel. Weeks before the start of the American Revolution, he was appointed a brigadier general in the Connecticut militia, becoming second in rank to New Haven's Major General David Wooster.

A few months later, after the Battle of Bunker Hill, the Continental Congress appointed four major generals to report to the newly appointed Commander in Chief George Washington. Spencer hoped to be named to one of the positions, but instead he was commissioned as one of Washington's first eight brigadier generals. The only Connecticut man to be commissioned

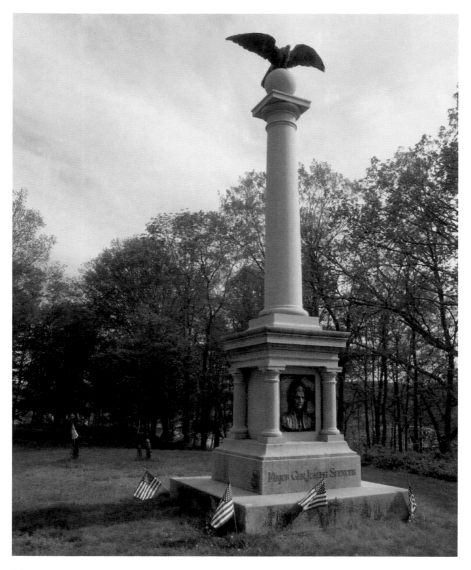

Monument to Revolutionary War general Joseph Spencer in East Haddam. At one time, he was the oldest active American general. *Authors' collection.*

a major general on the occasion was French and Indian War legend Israel Putnam, who also commanded troops at the Battle of Bunker Hill.

Although friends of Spencer in Congress and in the Connecticut government spoke up for his advancement, he remained a brigadier general. A year later, however, after meritorious service at Boston (in April 1776, his was the last brigade to leave Boston for New York), Congress

commissioned Spencer a major general in the Continental army. At sixty-one, he was the oldest active American general. (Three had been older, but Pomeroy chose to serve as a militia general, Wooster was killed in action and Frey had resigned.)

Spencer played a part in the Continental army's occupation of New York in 1776, and after Washington was pushed from the city, Spencer was given command of the Continental forces in the state of Rhode Island. While in that position, British general Richard Prescott was captured by Spencer's men and later exchanged for American major general Charles Lee. Spencer planned an attack on the British on Long Island but later called it off; subsequently, this action was investigated by Congress. Spencer resigned his commission, but in 1778, he was cleared of any fault by Congress.

Joseph Spencer served as a member of the Continental Congress in 1779 and died in 1789 at age seventy-four. He had a total of thirteen children (five by his first marriage and eight by his second). The Spencer monument next to the Nathan Hale Schoolhouse in East Haddam was dedicated in 1904, and the remains of Spencer and his second wife, Hannah, were reinterred next to it.

WASHINGTON TRAIL

George Washington passed through Durham on June 29, 1775, as he headed north to take command of the Continental army at Cambridge, Massachusetts. On this visit, he stopped to speak with Durham resident General James Wadsworth. Leaving Durham, Washington headed to Wethersfield, where he stayed at Continental Congress delegate Silas Deane's home.

Between October 15 and November 13, 1789, Washington (now president of the United States) retraced his 1775 route as he traveled from the national capital of New York City through Connecticut, Massachusetts and New Hampshire. On October 19, he traveled through Durham and Middletown. Arriving at Middletown, he remarked, "I took a walk around the town, from the heights of which the prospect is beautiful."

Washington's time in Durham and Middletown was probably similar to other stops on his tour: he discussed agriculture with farmers, reviewed militia units, spoke with local government leaders and stopped to see General Comfort Sage in Middletown. Thousands of men, women and children

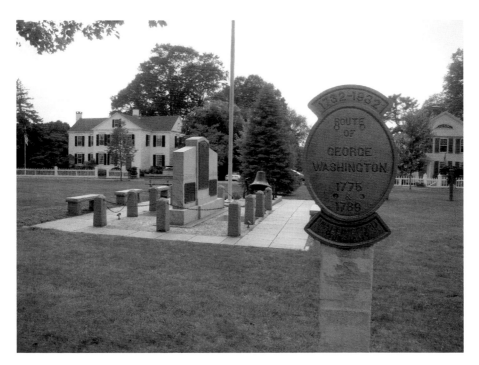

A Washington Trail sign stands on the Durham town green. A nearby monument displays the names of locals who served their country in wartime. *Authors' collection.*

turned out to cheer and, if fortunate, meet the person who, more than any other, was responsible for winning the American Revolutionary War.

In 1982, in celebration of the 250th anniversary of Washington's birth, Connecticut governor William A. O'Neill sent a time capsule from the State Library in Hartford to the Durham Fairgrounds to be opened at the same time as a similar Durham capsule. Both boxes were sealed on Washington's 200th birthday—February 22, 1932. The big event of the 1982 celebration was a walk along the Durham section of Washington's route. Buses took walkers from the fairgrounds to the beginning of the trail at the Durham-Wallingford line and later picked them up at the Durham-Middletown line.

Today, a sign on Durham's town green marks Washington's route. Appropriately, it stands next to a monument containing the names of local area people who served their country in the Revolutionary War, the War of 1812, the Mexican War, the Civil War, World War I, World War II, the Korean War, the Vietnam War, Desert Storm/Shield and Operation Enduring Freedom.

Submarine Inventor

David Bushnell, the son of farmers Nehemiah and Sarah Ingram Bushnell, was born in the Westbrook section of Saybrook in 1740. He was accepted by Yale College at age thirty-one. When the American Revolution began, Bushnell became absorbed with the ways the freedom-seeking colonies could confront British sea power. After numerous experiments, he developed a way to explode gunpowder underwater. Following his experiments at Yale, Bushnell created a one-man wooden submarine, nicknamed the *Turtle*, which could carry a mine filled with gunpowder. It incorporated a timing mechanism that would detonate after it was attached to the hull of a ship.

The *Turtle* was put into action on September 6, 1776, in New York Harbor, when operator Sergeant Ezra Lee attempted to attach the mine to the sixty-four-gun HMS *Eagle*. Due to the difficulty of drilling through the ship's iron plates, as well as the higher than expected tides, the mission failed. Commanding general Israel Putnam watched the operation and ordered the *Turtle* to be retrieved.

The following year, Bushnell tested exploding mines and attacked the HMS *Cerberus* in Niantic Bay, which was about twenty miles east of Bushnell's Westbrook birthplace. Both this effort and a floating mine attempt in the Delaware River failed. Still, General Washington recognized Bushnell's genius and placed him in charge of his army's engineering officers.

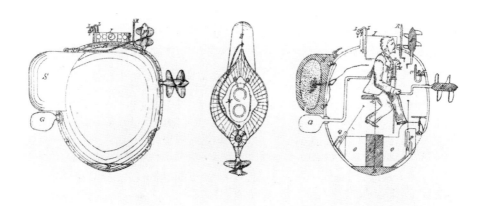

An engraving entitled *Bushnell's American Turtle* depicts three views of David Bushnell's one-man submarine. *Courtesy of the Library of Congress.*

In 1787, at age forty-seven, Bushnell left Saybrook and traveled to France, where he lived until around the mid-1790s. The reason for his trip is not known. He next shows up in history in 1803 in the state of Georgia, where, under the name David Bush, he purchased land. Twenty-three years later, Bushnell died, and his identity was revealed in his will. It's believed that he never married, never had children and never kept a diary.

Today, Bushnell's grave in Georgia is marked by a large stone that includes a three-dimensional carving of the *Turtle*. The U.S. Navy has named two submarine tenders after Bushnell: USS *Bushnell*, launched in 1915, which served in World War I, and a second USS *Bushnell*, which was launched during World War II.

ESSEX ATTACK

Local Native Americans called the area where Essex now sits Potopaug. English settlers first moved there in 1648, when it was part of Saybrook colony, and named it after Essex County, England, the home of some of the first settlers. From the 1600s through the 1800s, the town was best known as a leader in overseas trade and shipbuilding. Over six hundred ships were built in Essex, including the *Oliver Cromwell*, colonial America's first warship, which was launched on June 13, 1776.

Perhaps the most famous event in the town's history occurred during the War of 1812. On April 8, 1814, 136 Royal marines and sailors rowed up the Connecticut River, guided by a local resident, and landed at the site of today's Connecticut River Museum. They occupied the town and agreed not to harm residents or their homes if they promised not to resist. The town's militia didn't interfere, and the British burned twenty-eight ships, which were docked or under construction. The militia's decision was probably a good one; the town's defenses were weak, and no one was killed or injured in the encounter.

The destruction of the Essex ships would be the greatest maritime monetary loss to the United States until 1941's Japanese attack on Pearl Harbor.

Clinton's Cannons

Clinton's Waterside Lane is one of the most historic districts along the Connecticut coastline, populated by many late eighteenth-century and early nineteenth-century homes, several of which were built by sea captains. The oldest structure is the Arsenal, built in 1675 at the end of Waterside Lane as a tiny fort. In 1793, it was moved to its current location.

In 1814, the British fired on and burned the ships in Essex Harbor. Less well known is the assault on the town of Clinton (then the southern end of Killingworth). After learning that the shallow water off Clinton prevented their ships from coming near shore, the British fired several shots and left. One reason for their quick departure was the presence of a cannon in Clinton that was used in the American Revolution. Local militia had mounted the cannon on the green at the foot of Waterside Lane and counterattacked the British ship.

Originally, the Waterside Lane cannon was captured from an English privateer in the English Channel and sold to an English commercial vessel.

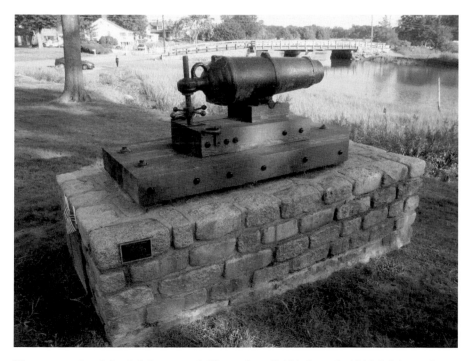

The cannon that defended the town of Clinton from British forces in 1814. It is located on Long Island shore in Clinton. *Authors' collection.*

That ship was wrecked on the Saybrook Bar, and the salvaged cannon was sold to a lighthouse keeper. The keeper then sold it to Captain James Farnham of Clinton (whose 1785 house still stands at 69 Waterside Lane). While leaving the area after the 1814 attack, the British frigate burned the smallpox hospital on Duck Island.

Today, the cannon still points out over Clinton Harbor at the foot of Waterside Lane. A second cannon that was also used in the War of 1812 sits next to the Abraham Pierson and Charles Morgan statues on Clinton's Liberty Green.

CHESTER'S INKWELLS

Chester's Silliman & Company was located by North Pattaconk Brook on North Main Street. Samuel Silliman started the firm in the early nineteenth century to manufacture various household items, including inkwells. He and the other owners were active deacons in the local Congregational Church.

Over time, Silliman & Company specialized in producing inkwells and related office products such as wax seals and portable desks. Distribution expanded nationwide, and Silliman inkwells were said to have been used by President Martin Van Buren and attorney Abraham Lincoln in Illinois.

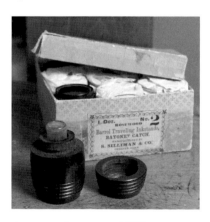

A carton of never-used Silliman & Company inkwells. Silliman inkwells were used by thousands of Union army soldiers during the American Civil War. *Courtesy of Tom Marshall.*

In its approximately eighty years in business, the company gained the most prominence from its patented pocket inkwells, which were made of wood with glass inserts surrounded by insulation. They were made secure by the use of screw tops. These portable inkwells were used by Civil War soldiers, who could now carry pen and ink into war so they could write back home to family and friends. In fact, it's been said that the availability of these inkwells was the main reason that there were so many letters written by Civil War soldiers.

The inkwells came in about a dozen styles, in different sizes and with various

designs. At any given time, the Chester factory employed about thirty workers, which usually included about six or seven women. The invention of the fountain pen in the late 1800s spelled the end of Silliman, and business declined dramatically. Production ceased a few years before the factory was sold in 1905.

African Americans

Escaped Slaves, an Honored Jurist and the First Female
African American Pharmacist

African Americans have always played a large role in Middlesex County history. In the 1700s and 1800s, many were born into slavery, and others were lifelong free men and women. When the American Revolutionary War began, many volunteered to serve in the Continental army and state militia units.

Slavery existed in Middlesex County, as in the rest of Connecticut, from colonial times. In 1790, there was approximately the same number of slaves and freed blacks in the entire state of Connecticut (totaling 2,759 and 2,801, respectively). In each of the subsequent censuses, the number of slaves decreased: in 1800 (951 slaves and 5,330 free blacks), 1810 (310 and 6,453), 1820 (97 and 7,844), 1830 (23 and 8,047) and in 1840 (17 and 8,105).

Estimates of the number of enslaved people in Middlesex County by decade are 1790 (208), 1800 (72), 1810 (57), 1820 (8), 1830 (2, both in Saybrook) and in 1840 (1). Slavery was not officially abolished in the state until 1848. As slavery disappeared in Connecticut, the fight to end slavery everywhere intensified—including in Middlesex County. In 1837, Deep River had an antislavery society with 60 members; East Hampton had 28, and Middle Haddam had 30. Middletown had two societies—one run by white residents, the other by African Americans. Some of the most committed Underground Railroad agents in Middlesex County were Jesse Baldwin and Benjamin Douglas in Middletown, Phineas Augur and William Lyman in Middlefield, Judge Ely Warner and Jonathan Warner in Chester and George Read in Deep River.

Among the tales of African American lives are narratives of suffering and abuse as well as stories of strength and courage. Unfortunately, we have room here to only describe a few of the major African American historical figures of Middlesex County.

VENTURE SMITH

Broteer Furro was born the son of a tribal chief in West Africa (probably today's Guinea) around 1729. When about six years old, he was captured with his family by a large warlike tribe, saw his father tortured and killed and was marched to the coast. There he was purchased by a New England slave trader who renamed him Venture, because (as Broteer would write many years later) he "purchased me with his own private venture." After the voyage across the Atlantic Ocean, Venture reached the man's home in Rhode Island.

Venture worked at such tasks as carding (cleaning and untangling) wool and pounding ears of corn for poultry food. As the years passed, he grew to be six feet, two inches tall and probably over three hundred pounds—he was considered a giant. His size was only equaled by his business acumen, intelligence and integrity. At about twenty-two years old, Venture married Meg, an enslaved African American woman, and they had a daughter. About a month after the birth, Venture was sold to a Stonington man named Thomas Stanton. He took with him money he had privately earned over the years by cleaning shoes, trapping small game, growing potatoes and carrots and fishing at night.

After learning his wife was unfairly accused of a minor offense by her master's wife, Venture came to her defense. After beatings by the master and the master's brother, Venture was handcuffed, and his legs were padlocked to a large ox chain. He was then sold to Hempsted Miner of Stonington, Connecticut, who unlocked him and promised to give him "a good chance to gain…freedom." As it turned out, Venture was resold three times before he ended up at the home of a Colonel Smith. In 1765, Smith allowed the thirty-six-year-old to purchase his own freedom.

Once a free man, Venture took up residence on Long Island, where over the next four years he worked at cutting several thousand cords of wood, saving his wages.

About four years later, Venture purchased freedom for his two sons, Solomon and Cuff, for $200 each. Cuff later served in the American

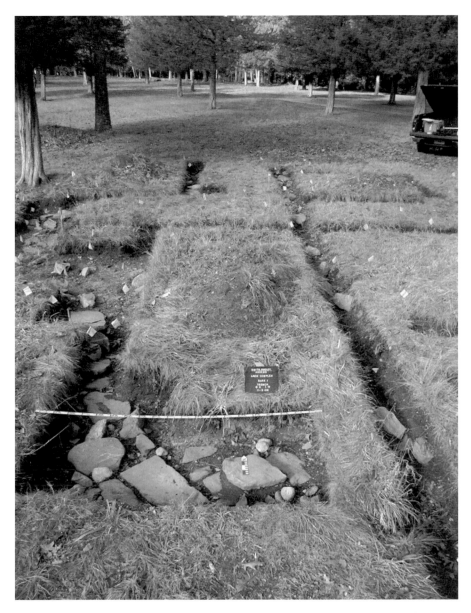

This is the site of one of Venture Smith's barns on his property in Haddam Neck. *Courtesy of Lucianne Lavin and Marc Banks, American Cultural Specialists.*

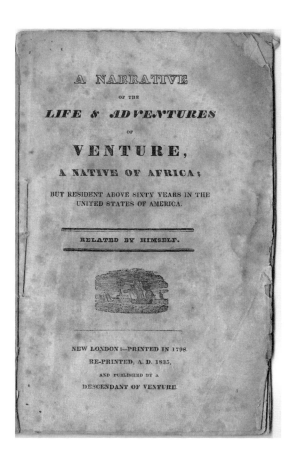

An 1835 edition of Venture Smith's autobiography, which was the first slave narrative to tell the story of an American slave's life in Africa. *Middlesex County Historical Society Collection.*

Revolutionary War, and a third, younger son fought in the War of 1812. In his forties, Venture chartered a boat and hired men to transport wood and produce between Rhode Island and Connecticut. He also completed a seven-month whaling voyage and, in his spare time, fished for eels and lobsters.

At age forty-four, Venture bought his pregnant wife out of slavery. A couple of years later, he purchased freedom for his daughter Hannah. Along the way, he bought freedom for three other African men. At age forty-seven, Venture sold his property on Long Island and moved to East Haddam. Shortly afterward, he purchased ten acres of land in the town's Haddam Neck section. Within three years, he bought another seventy-six acres and built a house and wharf.

In his autobiography, Venture disproved the old adage "You can't cheat an honest man," as he related how he was swindled and robbed by white and black men alike. In one story, a Captain Elisha Hart of Saybrook sued him

for the loss of a hogshead of molasses, which was not his fault. Advised by others that he should reimburse Hart, who was wealthy and would "carry the matter from court to court till it would cost me more than the first damages," Venture did pay. Later, Hart taunted him about it.

In 1798, the story of Venture's life was written down, probably with help from local schoolteacher Elisha Niles. Published as *A Narrative of the Life and Adventures of Venture, a Native of Africa, but Resident Above Sixty Years in the United States of America, Related by Himself*, it would be the first slave narrative that told the story of an American slave's life in Africa.

After expressing regret for his physical infirmities, Venture ended his life story with his "many consolations": "Meg, the wife of my youth, whom I married for love, and bought with my money, is still alive. My freedom is a privilege which nothing else can equal."

Venture Smith died on September 19, 1805, and is buried in the churchyard of East Haddam's First Congregational Church. Meg passed away four years later.

WILLIAM WINTERS

In the nineteenth century, Middlesex County towns played a key role in the network of active abolitionists called the Underground Railroad. The Connecticut River provided a convenient way to move people escaping slavery along the Atlantic coast northward toward Canada. At the time, the amount and variety of watercraft on the river was such that the movement of escapees might go undetected.

One man who traveled north and settled in Middlesex County was Daniel Fisher. Born into slavery on a Virginia plantation in 1808, Fisher was taken away from his family and sold to a South Carolina slave owner at age twenty. Seven months later, he escaped and made his way with a fellow slave back to his old plantation.

From there, Fisher stowed aboard a ship to Washington, D.C. Its captain found him and a companion and gave them food, and they walked north to Baltimore along a railroad track. From there, they continued to evade kidnappers as they reached Philadelphia, where the two men split up. Fisher made his way to New York City, where an abolitionist paid for his steamboat passage to New Haven. From there, Fisher walked the thirty miles to Deep River.

On the advice of abolitionist George Read, Fisher changed his name to William Winters and wore a wig to minimize the chances of being identified by bounty hunters searching for runaway slaves. It's been said that he chose the surname Winters because it was in winter that he found his new home. Over the years, other family members joined him in Deep River, establishing a thriving African American community in the center of town.

After the Fugitive Slave Act of 1850 was passed, Winters moved to Massachusetts, where he lived until the Emancipation Proclamation effectively made slavery illegal throughout the country. Later, he returned to Deep River, becoming a successful farmer and businessman. Winters died on November 22, 1900, at age ninety-two and was buried in Deep River's Fountain Hill Cemetery.

JOHN HARRIS

John "Jack" Harris was a slave living on a plantation in Danville, Virginia, on the North Carolina line before the Civil War. When he was still a young boy, his mother died, but not before she was assured by Mrs. Ayers, the mistress of the plantation, that her young Jack would be well cared for. He was—until he grew up. At age twenty-one, Jack married, and his wife bore two children. Regrettably, his wife and children were taken from him and sold to other slaveholders.

Jack traveled north and worked on a steamship that traveled between Boston and New York City. He engaged in farmwork and, at about age eighty, obtained a job as chef in the home of Portland medical doctor Cushman Sears and his wife, Evelyn.

In a 1913 *Hartford Courant* article, Jack Harris was described as one hundred years old, with a frail, bent form and snowy-white hair. It describes how every Fourth of July and Memorial Day, Harris would sit in front of his home with an American flag in his lap to watch the parade. Marching schoolchildren would cheer him, and Civil War veterans would salute him.

ANNA LOUISE JAMES

Anna Louise James was the ninth child of Anna Houston and Willis James; Willis had been a slave on a Virginia plantation before he escaped to Hartford, Connecticut, at age sixteen. In 1909, Anna became the first female African American pharmacist in the state of Connecticut. A graduate of Old Saybrook High School in 1905, she was the only woman and the only African American in her 1908 graduating class at New York's Brooklyn College of Pharmacy.

After Anna's graduation, she ran a drugstore in Hartford for several years before moving home to Old Saybrook to work in the pharmacy owned by her brother-in-law Peter Lane. When Lane left to fight in World War I, he placed Anna in charge. In 1921 or 1922, Anna became the sole proprietor and named her new business James Pharmacy.

Miss James, as she was called by the townspeople, continued operating the pharmacy until her retirement in 1967. She resided in an apartment in the back of the store until her death in 1977 at age ninety-one.

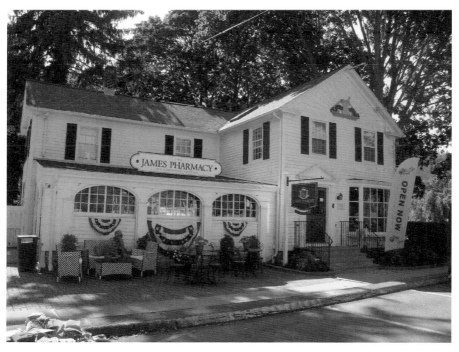

For almost half a century, African American pharmacist Anna Louise James owned and operated this pharmacy in Old Saybrook. *Authors' collection.*

Many Old Saybrook residents recall stories of James Pharmacy as a stopping place to gather local news, buy newspapers and magazines or enjoy an ice cream soda. Celebrated actress and longtime resident Katharine Hepburn was a regular visitor and friend of Miss James. Anna Louise James had a stern, yet trusted reputation while dispensing medicine and became a local legend to the shoreline community and its summer residents, who sometimes asked her to hold their vacant cottage keys during the winter.

As one of the first women to register to vote after the Nineteenth Amendment was passed (1920), Anna Louise James was politically active in the Republican Party. She hired young employees who said she had "exacting standards," but she was a "wonderful lady to work for." Townspeople said she was feisty and a very caring woman who operated her business 365 days of the year.

Her niece, author Ann Lane Petry, assisted her as a licensed pharmacist before moving to New York to pursue a career as a writer. Anna Louise James left an indelible mark both as a role model and as a well-respected businesswoman who was a successful, prominent proprietor before women even had the right to vote.

Today, the James Pharmacy building is home to the James Pharmacy Bed & Breakfast and Gelateria. Co-owners Paul Angelini and Eileen Sottile Angelini honor its history by retaining many of the building's internal fixtures. They named one of the guest bedrooms for Miss James and display books and memorabilia of her and Ann Lane Petry.

CONSTANCE BAKER MOTLEY

The daughter of immigrants from the Caribbean island of Nevis, Constance Baker Motley became a civil rights activist and the chief judge of the U.S. District Court for the Southern District of New York, a bench she served on for twenty years. From 1965 to 2005, she had a home in Chester, Connecticut, on Cedar Lake Road where she and her family would spend weekends, holidays and summers.

Motley was born in New Haven in 1921. After reading a book in which Abraham Lincoln noted the difficulties of being a lawyer, she decided she wanted to go to law school—despite the fact that her mother wanted her to become a hairdresser. In 1946, she received her law degree from Columbia University. As an attorney with the NAACP, she became a key player in the

successful efforts to end racial segregation in voting, public schools, colleges and public facilities.

She was the only woman on the legal team that won the landmark U.S. Supreme Court case *Brown v. Board of Education*, which held that racial segregation of students in public schools was unconstitutional. She was also the first African American woman to argue a case before the Supreme Court.

In addition to *Brown*, Motley was counsel in fifty-seven civil rights cases in the U.S. Supreme Court, eighty-two cases in federal courts of appeals and many other cases in federal district and state courts. The cases in which she was involved stretched across eleven southern states and four northern states between the years 1945 and 1965. Motley was also James Meredith's chief legal counsel when he fought to integrate the University of Mississippi, Additionally, she was the first African American woman in the New York State Senate and the first African American woman to occupy the role of Manhattan borough president.

When President Lyndon Johnson appointed Motley as a U.S. District Court judge, it was the first time an African American woman had been appointed and confirmed as a federal judge.

In 2001, President Bill Clinton awarded Constance Baker Motley the Presidential Citizens Medal, noting that "as a dedicated public servant and distinguished judge, she has broken down political, social, and professional barriers, and her pursuit of equal justice under law has widened the circle of opportunity in America."

Constance Baker Motley died in 2005 at age eighty-four.

4

EDUCATION

Connecticut's Teacher-Hero, the One-Room Schoolhouse and a World-Famous University

In Connecticut, as well as elsewhere in New England, the one-room schoolhouse was the norm up until the early twentieth century. In large area towns like Middletown or Killingworth, it was difficult for students to travel to centrally located schools, so the multi–grade level, one-room schoolhouses were placed in widely dispersed areas of a town. When Middletown built its high school in 1840, it was the first public high school in the state of Connecticut.

With the introduction of motor vehicles, particularly motorized school buses, students could be picked up near their homes and transported to central schools. Subsequently, most one-room schoolhouses were either demolished or converted into residences.

One of the disadvantages of the one-room schoolhouse was that students of different ages needed to be grouped together under one teacher. The teacher was responsible for giving appropriate lessons for all levels—it was challenging to school the emerging readers through grade eight learners in the same room. Memorization, repetition and recitation were key ingredients to their learning, and older children sometimes assisted the younger children.

Many people in Middlesex County remember these schools. Marty Machold remembered attending his one-room schoolhouse in Killingworth from 1946 through 1948.

NATHAN HALE

Perhaps the most famous one-room schoolhouses in Connecticut are the ones in which Patriot martyr Nathan Hale taught in New London and East Haddam. The latter was used as a school between 1750 and 1799 on the East Haddam green on Main Street (not far from today's Goodspeed Opera House). After spending the nineteenth century in another Main Street location, it was moved to its third and present location behind St. Stephen's Episcopal Church.

Hale was only an eighteen-year-old Yale graduate when he taught for six months in East Haddam. Although he was popular with the students and he loved teaching, Hale wrote to another former Yale student of the "remote life in the wilderness called Moodus." Shortly thereafter, he accepted a schoolmaster position in New London.

Nathan Hale soon went to war. He was employed by the Continental army as a spy in New York and was captured by the British. At his execution on September 22, 1776, he famously stated, "I only regret that I have but one life to lose for my country."

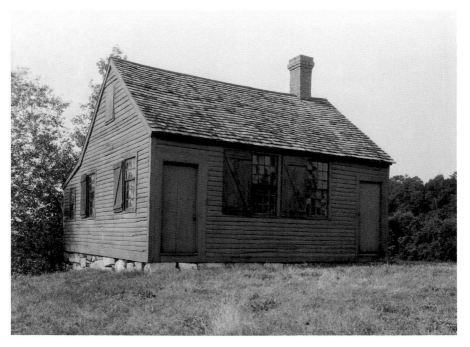

After graduating from Yale College, Nathan Hale taught in this one-room East Haddam schoolhouse for several months. *Authors' collection.*

CHARLES MORGAN

As large, central schools sprang up, so too did the need to finance them. Clinton was fortunate in this regard, as one of its native sons paid for the establishment and maintenance of its major school out of his own pocket.

After growing up in Clinton, Charles Morgan left for New York City at age fourteen to make his fortune. And he did; he predicted that steam power and iron hulls would replace wooden ships with sails. Morgan created the largest steamship company in America. Of the 150 ships he built and operated in his life, 4 were built in Clinton. In addition to his ships, Morgan also owned a major railroad that operated in Louisiana and Texas, and at the end of his life, he owned the longest railroad in the country controlled by a single individual.

In an effort to give back something to his hometown, Morgan gave $50,000 along with the land to build Morgan School, which opened in 1871 for all grade levels. At his death four years later at age eighty-three, he provided an endowment large enough to pay for the education of Clinton children for generations. It was only with the stock market crash in 1929 that it couldn't pay all expenses and required the town to step in and provide funding for its school. Three years after Morgan's death, a large statue of him was erected in front of this school.

In 1947, the first school building was judged unsafe because incorrectly installed fire escapes had weakened the structure. When it was demolished a few years later, a new Morgan School was opened. The Pierson School parking lot is on the site of the original school.

THE BEGINNING OF YALE UNIVERSITY

Middlesex County wasn't only well known for its high-quality elementary and high schools. It was also the place where one of the top universities in the world got its start. Although Yale University is always associated with New Haven, it began in lower Middlesex County in the Clinton section of Killingworth. (In 1838, the southern part of Killingworth would be incorporated as the Town of Clinton. The new town was named after the late DeWitt Clinton (1769–1828), the governor of New York State and the driving force behind the building of the Erie Canal.)

In 1701, the General Court of the Colony of Connecticut granted a charter for the Collegiate School, which would meet at the home of its first rector, the Reverend Abraham Pierson (1646–1707), in the southern portion of Killingworth, Connecticut. In 1718, the institution would be renamed Yale College (later Yale University).

ABRAHAM PIERSON

Born in 1646, Abraham Pierson graduated from Harvard in 1668 and was ordained a minister. After serving with his father's ministry in New Jersey, he moved to Killingworth (present-day Clinton) in 1694 and became its Congregational pastor until his death.

Although Pierson was appointed as the Collegiate School's first rector in 1701, because of ministerial duties in Killingworth, he didn't receive his first student until the following year. Although the school's trustees wanted him to move classes to Saybrook, members of his congregation vehemently objected, with the result that Pierson held classes at his home until he passed away in 1707. By the time of Pierson's death, eighteen students had received their bachelor's degrees from the school.

Pierson was one of three Yale presidents to die in office in the school's 316-year history. After his death, the Collegiate School seniors were sent to Milford to finish their studies, while the other students were tutored in Saybrook. After several years of disputes over the final location of the school, New Haven won out, and in the 1717–18 school year, its first building was constructed in that city.

Abraham Pierson is buried in Clinton's Indian River Cemetery, and his original grave marker is on display in the History Room of the Clinton Town Hall. In 1874, a bronze monument of Pierson was erected on the town green in Clinton by educator Charles Morgan. In 1933, Yale University founded the residential college Pierson College, between Park and York Streets in New Haven, and named it in his honor.

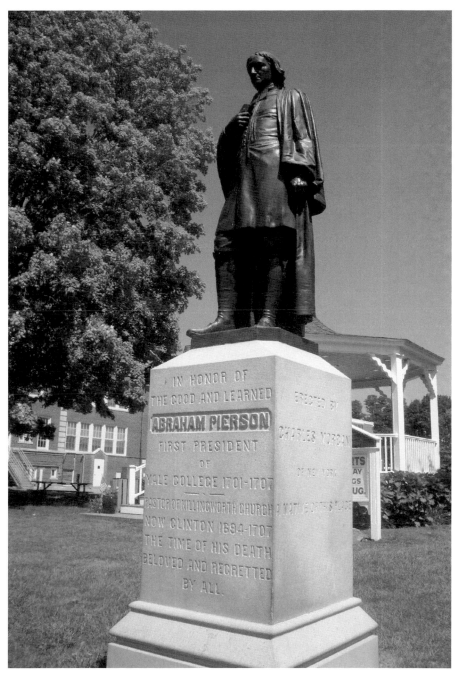

This statue in Clinton honors Abraham Pierson as the "First President of Yale College, 1701–1707," and "Pastor of Killingworth Church Now Clinton 1694–1707." *Authors' collection.*

WESLEYAN UNIVERSITY

In addition to Yale, one of the oldest private colleges in the country was established in Middlesex County's largest town, Middletown. Founded in 1831, Wesleyan University was the first college to be named after English preacher John Wesley (1703–1791), one of the founders of Methodism.

During its first year, Wesleyan consisted of three professors, one tutor, forty-eight students and two buildings that had been formerly occupied by Captain Alden Partridge's American Literary Scientific and Military Academy. Its curriculum included literature, natural sciences and modern languages, rather than just the study of classics and theology that was traditional in American schools. It also focused on community service projects.

Wesleyan was an all-male school until 1968, with the exception of the years 1872 through 1912, when women were admitted. Today's Fisk Hall, built in 1904, honors the university's first president, Willbur Fisk, who was well known as a Methodist preacher and an antislavery leader. In 1937, the school officially broke all ties with the Methodist Church.

Wesleyan University has produced many leaders in government (such as Connecticut governor, U.S. senator and state chief justice Raymond Baldwin), in literature (biographer and writer-in-residence William Manchester) and entertainment (Academy Award–winning songwriter Allie Wrubel).

One of the most colorful members of the faculty was Professor Charles Wilbert Snow. Known for his poetry and his close friendship with some of the great poets of the twentieth century, in the 1940s, Snow served as lieutenant governor of Connecticut and, for twelve days, governor. Snow's appointment to Wesleyan was controversial because of his leftist politics—he supported the League of Nations and campaigned for Progressive Party candidate Robert La Follette.

Today, Wesleyan has nine-hundred-plus student courses per year in addition to independent study courses. Its diverse student population numbers over three thousand students, and its faculty includes about three hundred full-time members. Its philosophy is "critical thinking and practical idealism go hand in hand."

HOLY APOSTLES COLLEGE AND SEMINARY AND MIDDLESEX COMMUNITY COLLEGE

Two other colleges call Middlesex County home. Holy Apostles College and Seminary located in Cromwell was founded in 1956 as a Roman Catholic seminary for men. It specialized in the education of middle-aged men going into the priesthood. After several years of operation, it opened its classrooms to male and female members of religious orders, as well as people of all religions.

Middlesex Community College was founded in 1966 as a branch campus of Manchester Community College, and it became an independent college in 1968. In 1973, it moved to its current thirty-eight-acre campus.

At its opening, Middlesex Community College's first president, Phillip D. Wheaton, stated, "I say to you that there is something about a new college, simple, naïve, still sudsy behind the ears, with dirt under its fingernails yet, that suggests that it be given a chance to try." It was given that chance, and today, residents from surrounding communities reap the benefit by attending Middlesex Community College's main campus or its branch location at Platt High School in Meriden. It also founded and sponsors two senior citizen–enrichment programs: MILE (Middlesex Institute for Lifelong Education, at its main campus) and CCALC (Castle Craig Adult Learning Center in Meriden, Connecticut).

THE DURHAM BOOK COMPANY

While looking at education in Middlesex County, it's important to remember that the mainstay of an educated community is the public library, and there are few locations in America that can claim as great a role in the creation of that institution than Durham, Connecticut.

The oldest lending library in the United States was Benjamin Franklin's Philadelphia Book Club, which started in 1732. One year after Franklin's club, the Durham Book Company became the second lending library in the country. The founding articles include the statement:

> *Forasmuch as the subscribers hereof, being desirous to improve our leisure hours, in enriching our minds in useful and profitable knowledge by reading, do find ourselves unable to so do, for the want of suitable*

This, the oldest portion of the Durham Public Library, was built in 1902 and held the library's entire collection until 1985. *Authors' collection.*

and proper books. Therefore, that we may be the better able to furnish ourselves with a suitable, and proper collection of books for the above said end, we do each of us unite together, and agree to be coparcenors in company together by the name of The Book Company of Durham, united to buy books.

Residents paid a fee to borrow books on agriculture, travel, religion and other topics. In 1794, General James Wadsworth was appointed the librarian. The Durham Book Company operated until 1856. In 1894, a second Durham library found a home in Durham's town hall. The Durham Public Library moved into its own 1,800-square-foot building in 1902. In 1985, an addition nearly quadrupled the size of the building, and in 1997, another expansion increased its size again.

LONG LANE SCHOOL

In July 1868, the general assembly selected Middletown as the location for its Industrial School for Girls. It was funded by the State of Connecticut—$10,000 plus $3 per week for each girl it housed—and by private donations. The Middletown site was chosen because it was halfway between New Haven and Hartford, was easily accessible by Connecticut River steamboats, had Wesleyan and community support and was already the site of Connecticut Valley Hospital for the Insane. Middletown appropriated $10,000 for forty-six acres of land for its twenty-four homeless and destitute inmates because "the State…should provide a suitable institution for the custody and proper education of delinquent girls, not as criminals to be punished, but as unfortunate children of unnatural parents or guardians, to be protected and trained for lives of industry and virtue."

Unlike many institutions of the time, the School for Girls allowed no racial segregation—all were required to sleep, eat and learn practical skills together that would assist them after they left the school. In 1917, Miss Caroline deFord Penniman became its first female superintendent and implemented new policies that allowed girls to be treated as young women in training rather than as delinquents—the girls earned privileges through good behavior. In 1921, the school was transferred to the State of Connecticut, its name changed to Long Lane Farm and new buildings were constructed. In 1943, Long Lane School continued to function as a juvenile correctional institution, where it housed, educated and reformed girls, rather than sending them to jail for their deviant or delinquent behavior. It provided vocational classes, sports and medical and counseling care.

In the 1960s, Connecticut's Department of Children and Youth Services took on the supervision of Long Lane School, and its population changed—juveniles who committed more serious crimes were now housed at the facility. In the 1970s, the school had a prison-like atmosphere—perhaps due to Meriden's Connecticut School for Boys closing in 1972—and housed both boys and girls. In the 1990s, it had solitary-confinement units, fences to prevent runaways and disagreements among authorities on how to service the diverse population. By the 1990s, the Department of Children and Families wanted outside placement for troubled youth; however, by 1998, the now overcrowded school (230 youths in residence) was doomed in its mission to rehabilitate troubled youth, especially since three-quarters of them had substance-abuse issues and the school had reduced its staff and programs.

A cemetery near Pine Street in Middletown contains the graves of girls and young women who were inmates at the Industrial School for Girls. *Middlesex County Historical Society Collection.*

Long Lane School, the only coeducational state-run residential facility, closed in 2003. Wesleyan University purchased the property in 2005 and razed many campus buildings. A small cemetery near Pine Street in Middletown contains the graves of twenty-seven young women who were inmates of the Industrial School for Girls. Their deaths occurred between 1878 and 1916, and they ranged in age from ten to twenty years old. At least one-half of them died of tuberculosis, with most of the others passing from pneumonia, typhoid fever or dysentery.

BUSINESS AND INDUSTRY

Ships, Brownstone and Piano Keys

In the 1800s, Middlesex County towns embraced the Industrial Revolution. Middletown became home to gunmaker Simeon North, who built possibly the largest factory in the country at the beginning of the century. At the end of the 1800s, Middletown's Wilcox, Crittenden & Company was the largest manufacturer of marine hardware in the nation.

In the late eighteenth century and all through the nineteenth century, business and industry took hold and prospered. Middletown, Portland, Deep River, Essex and other county towns were centers of shipbuilding and related businesses. Some towns specialized in one or two products and became world famous. East Hampton became the bell manufacturing capital of the nation. Deep River and Ivoryton, a village of Essex, virtually dominated the entire ivory manufacturing industry, while Portland quarries provided brownstone for the construction of major buildings in the United States and Canada. In the latter case, the transport of the huge blocks of stone would have been impossible without the fortunate location of the quarries situated right on the bank of the Connecticut River.

CROMWELL'S IRON TOYS

Established in 1843 by brothers John and Elisha Stevens, Cromwell's J.&E. Stevens Company became the United States' largest manufacturer of tin and cast-iron toys.

Though it started out as a manufacturer of hardware products such as hooks, pins and screws, the company soon specialized in toys. In the 1850s, J.&E. Stevens produced one thousand pounds of iron wheels for children's toy wagons each week, in addition to its many other products.

Throughout the 1800s, the company's bestselling items were its mechanical banks. At the time, many of Stevens's toys were sold through the mail-order catalogues of companies like Sears Roebuck. Over the years, the company made over three hundred models of mechanical banks. Some of these intricately designed banks included the "Boy Scout Camp," "William Tell," "Indian Bear Hunt," "Squirrel and Tree Stump Bank," and the "Bowing Man in Cupola Bank."

Likely Stevens's most conscientious employee was Katherine "Kate" Ralph. Beginning employment at age sixteen, Kate became a toy painter and wrapper. She was still working a 7:00 a.m. to 4:30 p.m. shift five days a week at age eighty-one. Even at that advanced age, Kate walked a six-mile round trip to and from the Nooks Hill Road factory. After work, she

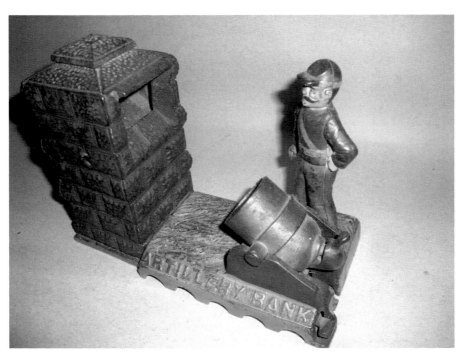

This painted cast-iron "Artillery Bank" was manufactured by J.&E. Stevens Company of Cromwell. *Authors' collection.*

delivered eighteen newspapers on the way home and finished the day by working on her farm with her younger brother and sister.

In a 1929 *Hartford Courant* article, Kate remembered that she was only on the job for one month when news arrived that President Abraham Lincoln had been assassinated, and the company's bell rang repeatedly.

In the twentieth century, following changing consumer demands, J.&E. Stevens Company switched over much of its production facilities from mechanical banks to cap guns. It prospered until World War II, when limitations on the use of iron in civilian products virtually destroyed its business.

In the 1860s, co-founder Elisha Stevens built his home at 385 Main Street in Cromwell. The Italianate house is now part of Autumn Lake Healthcare facility. Since 1964, most of the Stevens's factory buildings have been owned by Horton Brasses Inc., a leading manufacturer of authentic reproduction cabinet and furniture hardware.

CROMWELL'S ROSES

Cromwell's A.N. Pierson Inc. was to flowers what J.&E. Stevens was to metal banks. Founder Anders Pierson immigrated to the United States from Sweden in 1869 at age nineteen. A few years later, he moved to Cromwell, changed his name to Andrew and went into the flower-growing business. His Pierson Floral Nursery became A.N. Pierson Inc. in 1908, and it concentrated on growing roses. So successful was the company that Cromwell acquired the nickname Rosetown. By 1925, Pierson was the second-largest flower grower in the world. Although A.N. Pierson Inc. survived under Pierson family management for almost 120 years, rising energy costs and foreign competition resulted in it going out of business in 1991.

IVORY PROCESSING IN DEEP RIVER AND ESSEX

Beginning in 1809, Deep River's Pratt, Read & Company made products from elephant ivory. Starting with ivory hair combs, the company branched out into the more lucrative ivory-coated piano keys. The largest elephant tusks could provide enough key-covering material for about fifty pianos.

The plaque on this statue in Deep River reads "We Honor the Elephant…Deep River remembers its debt to this majestic creature." *Authors' collection.*

Close to one million elephants were killed between 1840 and 1940 to supply ivory for the Connecticut piano keyboard industry.

From the start of the Civil War until just prior to World War II, Ivoryton was the workplace and home to 600 to 1,400 workers, many of whom were immigrants from such places as Italy, Poland, Germany and Sweden. Most residents were employees of Pratt, Read or Ivoryton's Comstock, Cheney & Company. The two companies eventually controlled almost all ivory processing in the United States.

In the mid-twentieth century, plastic piano keys replaced ivory, and the remaining Connecticut ivory business was transferred to lower-wage southern U.S. states. The last shipment of ivory to Ivoryton occurred in 1954, and Pratt, Read & Company discontinued its piano parts business in the 1980s.

Today, the expansive four-story red brick building on Main Street that Pratt, Read & Company built in 1883 is home for the appropriately named Piano Works Condominiums. The best known remaining structure of Comstock, Cheney & Company is the Ivoryton Playhouse building.

EAST HAMPTON'S BELLS

Part of the Middletown colony, East Hampton was settled in 1710 on the Connecticut River. Later, many of its families resettled around Lake Pocotopaug. In 1746, they selected the name East Hampton. In 1767, the town separated from Middletown and incorporated using the name Chatham. Portland broke away in 1841, and the name Chatham was changed back to East Hampton in 1915. Connecticut includes another town named Hampton, but it is about thirty-five miles northeast of East Hampton.

East Hampton's proximity to the Connecticut River allowed it to develop into a shipbuilding center. The construction of an iron forge in about 1743 at a stream originating from five-hundred-acre Lake Pocotopaug supported this industry. Later, East Hampton became home to other businesses using iron; some of these products included waffle irons, coffin trimmings and kettles. Nevertheless, the major product that this community was identified with was its metal bells—church bells, house bells, bells for farm animals, bells for sleighs, bells for ships and bells for toys.

East Hampton's bell-making industry began with William Barton in 1808. Later, two of his indentured servants, Abner and William Bevin, began casting their own bells after completing their required service to Barton. They formed a company that was eventually named Bevin Brothers. Along with thirty other bell-related companies in town in the 1800s, they helped give East Hampton the name "Belltown, USA." This term survives today in the National Register of Historic Places, where a 145-acre section of East Hampton is designated as the Belltown Historic District.

East Hampton's bell business achieved some fame after the Great Chicago Fire of 1871. Chicago's courthouse was destroyed and its large bell damaged beyond repair. The company that bought the bell's remains sent pieces to East Hampton so Bevin Brothers could recast it into thousands of tiny bells that could be worn as jewelry. This was not the first time the metal was recycled—the Chicago Courthouse bell itself was partly composed of metal from a cannon that was used at the Fort Dearborn Massacre in 1812.

As the twentieth century saw the dramatic decline in the use of animal bells, some of East Hampton's bell companies switched their production to metal toys; however, the companies continued to decline, eventually disappearing. Only one company remained by the early twenty-first century—Bevin Brothers. Over the decades, Bevin bells have been

commonly found on Good Humor trucks, they have opened and closed the New York Stock Exchange and about one million of its bells have been used by Salvation Army bell ringers. Today, Bevin is the only U.S. bell maker whose only products are bells. Its president, Matt Bevin, is a great-great-great grandson of one of its founders and the current governor of Kentucky.

Portland's Immigrants

Just as East Hampton came to be known as Belltown, Portland earned its title "Brownstone Town" for its quarries of brownstone. Portland was known throughout the state and the nation for cutting that stone and transporting it locally and by ship and rail as far away as California and Canada. Among the buildings constructed with Portland brownstone were the New York City homes of Cornelius Vanderbilt and his son William H. Vanderbilt, who are often cited as the richest individuals in America between 1850 and 1885.

The Portland area was also believed to have more semiprecious stones than almost anywhere else in the country. Even though the mining of brownstone may have started as early as the late 1600s, it wasn't until the 1800s that it reached its peak. It was then that the Irish workers began to arrive.

The 1840 census of Chatham, which included Portland and East Hampton, revealed only about 25 people from Ireland—almost everyone else was of English ancestry. In the subsequent ten years, many young, single Irish immigrants came to work in the brownstone quarries, living in nearby homes and boardinghouses. Soon, they were joined by family members and by others from back home. A tremendous increase of Irish immigrants was seen as the century came to a close, especially with the need for more workers; the 1880 census stated about 1,000 of the 2,905 residents of Portland were Irish. In the 1870s and 1880s, many of the Irish settled in the Portland area, and St. Mary's Church, along with its school, were built nearby on Freestone Avenue.

In the 1870s, many immigrants also came from Sweden—by 1880, almost five hundred of them—with most finding work in the quarries. By 1890, many Catholic and Jewish immigrants arrived from Russia and Poland. In particular, the Eastern Tinware Company employed many Jewish workers. In the 1890s, the going rate of pay for its workers was $1.50 for a sixty-hour

Portland's quarries acquired a reputation in the nineteenth century as producers of some of the best brownstone in the United States. *Middlesex County Historical Society Collection.*

work week, and a five-room residence in Portland could be rented for about $6.00 a month.

Portland's Jewish population began a synagogue in private homes and rented buildings. Later, many moved to Middletown, where they founded Congregation Adath Israel. The next large group of Europeans was of Italian descent. Most came from the Sicilian town of Melilli, enticed by the prospect of better lives for themselves and their children.

Although quarrying brought wealth to its owners and steady paying jobs for workers, it was strenuous and dangerous. An average day in the Portland quarries in the 1800s would begin at 6:00 a.m. and end at nightfall, with a two-hour break in the middle of the day. In the late 1800s, teams of oxen and horses were replaced by work trains. Steam-powered hoists pulled by steam locomotives would move the rough-cut stone to finishing sheds and afterward to boats on the Connecticut River. The Middlesex Quarry Company advertised three quality levels of brownstone: "A1" for "fine residences" and monuments; "No. 2" for

warehouses, churches and trimming jobs; and "Course junk stone" for piers, walls and foundations.

One example of the danger of working in the quarries is the case of seventy-year-old stevedore Horace Markham of Portland, who in the summer of 1894 was rushed to Hartford Hospital, where his foot required amputation. A worker at Portland's Brainerd quarry for fifty-three years, he was loading a fifteen-ton piece of brownstone onto the steamboat *Helen P.* when he heard the cracking of the crane, signaling it was about to break. Markham's fellow worker jumped and escaped injury, but Markham became caught between the falling crane and a stone on the dock. It was the first serious injury he had ever received. Despite the foot surgery, he died two weeks later.

At the turn of the twentieth century, the demand for brownstone fell due to the availability of less expensive materials like concrete. Still, the quarries stayed in operation until the 1936 spring flooding of the Connecticut River, which rose to the record height of thirty feet, inundated the quarries and damaged equipment. Although recovery had begun, the hurricane of 1938 resulted in a second flooding of the quarries.

Presently, the Portland brownstone quarries are used as a recreation park with activities that include water slides, zip lines, swimming, snorkeling and canoeing. Another section has been reactivated as a small quarry of stone used for the restoration of brownstone buildings.

ESSEX BLACKSMITHS

Lieutenant William Pratt was one of Essex's three original settlers. His son, John Pratt Sr., opened a blacksmith shop in Old Saybrook in 1678. Later, it moved to Essex, and for a total of nine generations, the Pratt family ran their blacksmith business in town. Just about every imaginable metal object for house, farm and shipyard was made by the Pratts. In 1938, the smithy was commemorated by the U.S. Postal Service on a First Day envelope in a series celebrating the American entrepreneur, citing the Pratt Smithy as America's oldest continuously run family business. The Pratts were Essex blacksmiths for a total of 266 continuous years.

Today, the Pratt House in Essex sits near the family's last blacksmith shop at its location on West Street. The house was owned by four generations of Pratt family blacksmiths, beginning with John Pratt Jr. The 1701 house was moved back from the road and, in 1732, a two-room cape added to it; throughout its later additions, it remained in the family until 1952.

Middlefield's Nails and Guns

Manufacturing has always been a large part of Middlefield's economy, beginning with a paper mill in 1793. Five years later, a factory was built to make nails. It is said to have been the first time nails were made by machines in the United States. In 1793, a gunpowder mill was erected. An 1884 history of the town proudly declared: "It is quite remarkable that during more than 90 years of powder making only one life has been lost by explosion."

Perhaps the most well-known products of Middlefield industry were gun-related items. It began with a pistol-making factory in 1845. In the late 1800s, William Lyman patented the Lyman's No. 1 Tang Sight, which had a small disc and a large aperture. This so improved the vision of the shooter, Lyman was able to establish the Lyman Gun Sight Company. In 1925, it expanded its product line by purchasing Ideal reloading products and Ideal reloading handbooks. Today, Lyman Products Corporation is located at 475 Smith Street in the Westfield section of Middletown.

Retail Establishments

Throughout the county, retail establishments sprang up and grew in response to the increase in its population. In Middletown, the names Wrubel, Bunce, Shapiro, Pelton and Bishel became as well known as the names of U.S. presidents. To one extent or another, each of the other fourteen county towns had business areas with familiar names. They included grocery stores, restaurants, clothing stores, gas stations, pharmacies and other retail establishments serving the local population. Too numerous to mention, only a few of these companies can be spotlighted here.

Pharmacists in East Hampton and Westbrook

After moving to East Hampton when he was fourteen, Earl Hitchcock worked for the town's Chatham Stores. After obtaining his pharmacist license in 1912, he was given responsibility for the store's drug department. He later teamed up with two other department managers to buy out the original

A man of many talents, William J. Neidlinger was a Westbrook pharmacist and a professional photographer. *Courtesy of Cathie Neidlinger Doane.*

East Hampton pharmacist and probate judge Earl Hitchcock. *Courtesy of Nancy Thurrott.*

owner. Hitchcock worked as one of the store's owners and its pharmacist until 1949, at which time illness forced him to work part-time, alongside his son, also a pharmacist, who took over most of the daily duties. In the 1950s, Earl Hitchcock estimated that he had filled more than two-thirds of the ninety thousand prescriptions that he had on file—original paperwork that went back to 1905. Additionally, Earl Hitchcock was also a probate judge before his death at age sixty-five in 1955.

Born in 1876, William J. Neidlinger worked as a pharmacist at New York Hospital before—at age twenty-five—he bought out a drugstore in Westbrook, Connecticut. While serving as a pharmacist, he became well known as a photographer, and hundreds of his images of Westbrook and Old Saybrook were used on professional postcards. The county towns of Killingworth, Essex, Deep River and Chester also provided material for Neidlinger photographs.

A man of many talents, William Neidlinger was a founding member of the Westbrook Orchestra and played the violin, cello, mandolin and piano. In addition, he was an active member of the fire department, a projectionist at the local silent film theater and one of Westbrook's major real estate investors.

The image on the postcard of Bill Hahn's Hotel in chapter 9 was taken by Neidlinger. Another well-known pharmacist who must be mentioned is Anna Louise James of Old Saybrook. Her sage wisdom is still remembered by many old-timers, and more about Miss James can be found in chapter 3.

ESSEX'S INN

The Griswold Inn in Essex, built in 1776 by Sala Griswold, is the oldest continuously operating tavern in the United States. It is also said to be the first three-story building in the area. Its rich history includes the time during the War of 1812 when it was occupied by British troops. In the early 1800s, Essex became a stop for steamboat lines traveling between Hartford and New York City, and the Griswold Inn accommodated many of their passengers.

The taproom section of the inn was a 1735 schoolhouse that was rolled down Main Street on logs. It was then attached to the inn in the nineteenth century and used as a billiard room. Since then, its ceiling has been "painted" with oyster shells. The "Gris" is known for its oil paintings of steamboats and sailing ships, as well as other historical artifacts that grace its walls.

The Griswold Inn in Essex, the oldest continually operating tavern in the United States. *Authors' collection.*

Back in 1955, the Griswold Inn featured a special promotion for one cold February night. It charged what it estimated would have been 1855 prices for its menu items. A diner's choices included roast beef, lobster and swordfish. The price for any of these entrees was ninety-eight cents.

MIDDLETOWN'S CHAFEE HOTEL

Being the only major city in the county, Middletown naturally needed to provide housing for its visitors. In the early 1800s, guests enjoyed their stay at the Mansion House, the Central Hotel or the Farmers and Mechanics Hotel. The McDonough House was popular in the late 1800s, while the Chafee Hotel reigned supreme at the end of the century and into the 1900s. Of the other establishments, the Arrigoni Hotel on Main Street's north end was a standout.

Middletown's Chafee Hotel tablecloth with the signatures of John Philip Sousa and other celebrities of the late 1800s and early 1900s. *Middlesex County Historical Society Collection.*

Being on a major steamship line from Hartford to New York City, as well as being a hub for railroad traffic, Middletown was visited by many famous people during the late 1800s and early 1900s. Some left a record of their visit by autographing a tablecloth that the Chafee Hotel reserved for that purpose.

The great American composer and conductor, John Philip Sousa (1854–1932) was one of the Chafee guests who signed the cloth, now preserved by the Middlesex County Historical Society. Later, Bertha Chafee, the proprietor's wife, or her mother-in-law, Matilda Chafee, stitched over Sousa's signature. Other celebrities, some of whom were performing at the Middlesex Theater, did likewise.

Two legends of prizefighting history also signed the tablecloth: James J. "Gentleman Jim" Corbett (1866–1933), whose name appears to the upper right of Sousa's, and British boxer Bob Fitzsimmons (1863–1917), whose signature is to Sousa's lower left. Corbett defeated John L. Sullivan to become the second heavyweight champion in history, and Fitzsimmons beat Corbett to become the third man to hold the heavyweight title.

Also on the cloth are stage actor John Drew (1853–1927), who was the uncle of John, Ethel and Lionel Barrymore, and DeWolfe Hopper, husband of Hollywood columnist Hedda Hopper. DeWolfe and Hedda had one child, William DeWolf Hopper Jr., who played private detective Paul Drake on the classic TV series *Perry Mason*.

In today's Middletown, the wide variety of top-quality restaurants have replaced the inns and hotels of the past.

6

TRANSPORTATION

Ferries, Covered Bridges and Railroads

B y far, the most important geographical feature of the county has always been the Connecticut River. Even in prehistoric times, the native tribes were usually separated by the Great River, which runs north to south for four hundred miles—from today's Canadian border to what is now called Long Island Sound. With the population exploding at the arrival of European immigrants, the Connecticut River became important as a means for quickly moving people and their commodities, as well as transporting any merchandise that was required by the people of central Connecticut.

However, the Connecticut River posed more of a challenge for the local population because it divided the county. To ford the river by swimming was usually impossible with its currents and river traffic. Trade and transportation were dependent largely upon riverboats and ferryboats, which traversed the river during the pre–motor vehicle years. The first ferryboats were either rowed with long oars or equipped with sails. Later, the permanent ferryboats ran along cables that were attached to each side of the river, and horses on treadmills were used to turn the paddle wheels.

In 1819, one of the most celebrated historical writers of the time observed: "The width, the force, and especially the navigation of the Connecticut [River], are such as to render it very improbable that bridges will ever be thrown over it, within the bounds of this [Middlesex] county."

Ferry Services

In the 1600s, two ferry services were established in Middlesex County to cross the Connecticut River: the Saybrook Ferry, which ran between Saybrook and Lyme and was established in 1662, and Chapman's Ferry, which connected Haddam and East Haddam starting in 1695.

In the 1700s, the Saybrook and Chapman's Ferries were joined by Brockway's Ferry, which crossed between Essex and Lyme (1724); the Middletown Ferry between Middletown and Chatham (Portland) (1726); the Upper Houses Ferry between Middletown's Upper Houses (Cromwell) and Chatham (Portland) (1759); the Higganum Ferry between Haddam and Middle Haddam (1763); and Warner's Ferry between Chester and Hadlyme (1769).

The 1800s saw the introduction of Knowl's Landing Ferry between Middletown and Middle Haddam (1806); East Haddam Ferry between Haddam and East Haddam (1811); and the Haddam Ferry between Haddam and Middle Haddam (1814).

Of the ten Middlesex County ferries, only Warner's Ferry between Chester and Hadlyme has survived—in 2017, it celebrated 248 years of continuous operation. In the late 1800s, the ferries lost their monopoly on lower Connecticut River traffic with the construction of the railroad bridges in Middletown and Old Saybrook. The Shore Line Bridge at Saybrook Junction was built in 1870, and the Air Line Bridge in Middletown was completed in 1872. This made a more long-lasting solution; with the placement of permanent foundations in the river and the construction of railroad and vehicle bridges, people and their products could now easily and reliably cross the river.

Haddam Ferry

Motorists passing over the East Haddam swing bridge probably never give a thought to the days before it was built. Unlike the Arrigoni Bridge between Middletown and Portland, this bridge was not preceded by a wooden structure. Before it opened on June 14, 1913, the only way for a vehicle to cross that stretch of the Connecticut River was by boat or to wait for the river to ice up sufficiently to support traffic. Both alternatives were precarious and unreliable.

The type of ferry located at the Haddam–East Haddam site varied over the centuries, starting with the Native American canoe and progressing through the raft, the chain scow (which was powered by the river's current), the horse ferry and the steam ferry.

Perhaps the most serious problem facing the ferry in crossing between Haddam and East Haddam was winter travel. In the depths of Connecticut's winter, the river would freeze to the extent that it was too thick for a ferry to pass but too thin for people to cross on foot. Ferry boat captains, who could break through up to six inches of ice, would run continuously during this time to keep an ice-free passage open as long as possible.

Several ferries serviced this stretch of the river, approximately where Goodspeed Opera House now sits. The oldest was the Chapman Ferry, named after Captain John Chapman, who was granted the right to establish a ferry there by the Connecticut General Assembly in 1694. As a captain in East Haddam's south militia company, Chapman built his home where the Gelston House restaurant now stands. The only ferry older than Chapman's in Middlesex County was the one that ran from Saybrook (now Old Saybrook) to Lyme beginning in 1662.

In the mid-1700s, the fare for the East Haddam ferries was set by the General Assembly: two pence for a "man, horse and load" and three-fourths pence for a footman. Over the years, varying rates were charged for oxen, cattle, sheep and hogs.

In the decades before the bridges made ferryboats at East Haddam obsolete, there were four boats transporting people and their animals: the *W.H. Goodspeed*, named for the founder of Goodspeed Opera House; the *W.R. Goodspeed*, named for his son; the *F.C. Fowler*, named for a state representative who was also president of the Moodus & East Hampton railway; and the *General Spencer*, named for the American Revolutionary War commander.

The *General Spencer* was especially powerful, able to transport either fifty-five tons of freight, 120 people or three of the lightweight, early-twentieth-century cars. Today, the Chester Ferry still is operational to those who choose this means of seasonal transportation. Commuters pay a reduced monthly rate when purchasing tickets to board the ferry; day-trippers can pay for a one-way fare, relaxing outside their cars as they glide across the river and appreciate the scenic view of Gillette Castle perched up on a hill.

CHESTER–HADLYME FERRY (1769)

Jonathan Warner of Chester, who owned land on both sides of the Connecticut River, began the Chester–Hadlyme Ferry in 1769 as Warner's Ferry. During the American Revolution, the ferry transported supplies for Washington's Continental forces across the river. It continued operation as a private business until 1877, when it was taken over by the Town of Chester. Since 1917, it has been owned and operated by the Connecticut State Department of Transportation.

Today's Chester–Hadlyme Ferry is the diesel-powered, sixty-five-foot-long and thirty-foot-wide *Selden III*. Before it could be placed in service in 1949, the ferry slips needed to be overhauled—the greater weight of the new ferryboat made it impossible to load and unload cars.

With a maximum capacity of nine cars and forty-nine passengers, *Selden III* is far larger than the state's other Connecticut River ferry, the Glastonbury-Rocky Hill Ferry, which consists of a three-car barge pulled by a diesel-powered towboat. However, the latter is 114 years older and holds the record for the oldest continuous ferry service in the entire United States.

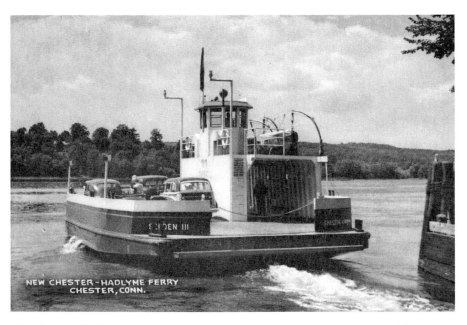

The Chester–Hadlyme ferry in the 1950s. Established in 1769, it is the second-oldest continuously operating ferry in Connecticut. *Courtesy of the Chester Historical Society.*

The scenic Chester–Hadlyme Ferry attracts thousands of visitors each year. Some people were introduced to the ferry by a scene in the 1961 movie *Parrish*, which stars Troy Donahue, Claudette Colbert and Karl Malden, or by the boat's appearance in the 1971 thriller *Let's Scare Jessica to Death*.

STEAMBOATS

After the War of 1812, steamboat travel became the norm on the lower Connecticut River. In 1824, the steamboat *Oliver Ellsworth* was put into operation. Next, in 1825, the steamboat *McDonough* was added; in 1830, the *Victory* was moved from Albany, New York. Three years later, the *Water Witch* achieved recognition for a thirteen-hour trip between Hartford and New York City. Other lower Connecticut River steamships of the 1830s and 1840s carried historical names: *Chief Justice Marshall*, *Bunker Hill*, *Lexington*, *Cleopatra*, *Charter Oak* and *Kosciusko*.

A decade later, the trend moved from historical names to mostly geographic names, so after 1850, one might notice these ships chugging up the Connecticut River: *Granite State*, *City of Hartford* (named the *Capitol City* after being refitted in 1883), *City of Middletown*, *Hero*, *Connecticut*, *New Champion*, *City of New York* (which after an 1881 sinking was rebuilt and renamed the *City of Springfield*) and *Silver Star*.

THE *GRANITE STATE*

In 1883, the Connecticut River steamboat *Granite State* burned, and five people were lost—four by fire and one by drowning. Fortunately, about fifty passengers and crew survived.

The vessel, owned by the Hartford and New York Transportation Company, was on its way toward Hartford with a full load of passengers and freight. After a fire was spotted near the steam chimney, the crew attempted to extinguish the flames. Unfortunately, the ropes tying the boat to the dock had burned, and it drifted downriver one-half mile to the upper end of Lord's Island.

After the boat broke away from the dock, one passenger jumped overboard from the upper deck to escape the flames. He was picked up by a small rescue boat and brought to shore. When he spotted four bales of cotton on the dock that looked like similar cargo on the burning ship, he thought he was back on the *Granite State*. He jumped back into the water and swam halfway across the river before he realized his error and returned to the shore.

As the century came to a close, steamboats began to give way to what people believed was a faster, safer, more reliable method of transportation—railroads.

CONNECTICUT VALLEY RAILROAD

During 1870 and 1871, tracks were laid from Middletown to Saybrook for the Connecticut Valley Railroad (CVR). The project was relatively easy since it ran parallel to the Connecticut River along mostly flat riverside land. No tunnels or bridges were needed along the entire length. When the turntable and roundhouse were constructed at Saybrook Point, the seventeenth-century earthen works fortifications were destroyed and the grave of pioneer settler Lady Fenwick was moved to Cypress Cemetery.

In 1872, the line was extended to Old Saybrook's Fenwick borough. In 1882, the New Haven Railroad bought the Connecticut Valley Railroad. During its heyday, the CVR ran five trains each way from Hartford to Saybrook Point.

In 1915, the Saybrook terminal was closed and the roundhouse destroyed. The New Haven Railroad donated the land to the State of Connecticut, and today, the location of the Old Saybrook turntable is part of a park maintained by the Town of Old Saybrook. Much of its track in Essex and Deep River is used by the Valley Railroad Company, which operates the Essex Steam Train & Riverboat tourist railroad.

Last remains of the Connecticut Valley Railroad roundhouse and turntable in Old Saybrook. *Authors' collection.*

COMSTOCK BRIDGE

Built in 1873, East Hampton's Comstock Bridge, which spans the Salmon River, is of the Howe truss design, with diagonal wooden beams and vertical iron rods. In later years, the Howe truss design was often used for steel railroad bridges. The Comstock Bridge is composed of two spans: the eighty-foot-long Howe truss span and a thirty-foot-long uncovered span. The Comstock allowed horse-driven buggies and automobiles to cross the Salmon River until 1932, when a new bridge opened downstream. It has been repaired a number of times: in the 1920s after a truck fell through its floor, in the 1930s when the Civilian Conservation Corps (CCC) added the bridge's wooden gates while replacing the siding with wood salvaged from a barn and finally in 2011 for an overhaul to preserve and protect the bridge.

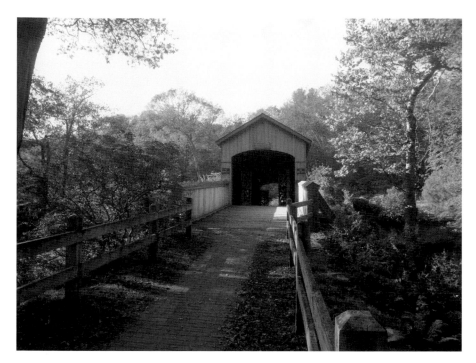

East Hampton's Comstock Bridge is one of the last three historical covered bridges in Connecticut. The other two are in Litchfield County. *Authors' collection.*

Today, the Comstock Bridge is no longer used for vehicular traffic and sits as an attraction within a public park. Visitors walk across this bit of history as they hike along the Salmon River Trail. It is one of only three historical covered bridges in Connecticut and the only one located in Middlesex County. The others, the 1864 West Cornwall Covered Bridge and Kent's 1870s Bull's Covered Bridge, stand in Litchfield County.

Although Comstock stands alone as a prime historical example of the Howe truss design, there are other covered bridges in Middlesex County. Some of the most famous are the Devil's Hopyard Bridge and the Johnsonville Village Covered Bridge, both in East Haddam; Olson's Covered Bridge in Deep River; and the Chatfield Hollow Bridge in Killingworth.

ARRIGONI BRIDGE

The only highway bridge across the Connecticut River between Haddam and Wethersfield is the 3,428-foot-long Arrigoni Bridge, which connects Middletown and Portland. It was built between 1936 and 1938 to replace an 1895 bridge and provided work for people suffering from the Great Depression.

To help with upper-level construction, Bethlehem Steel Company employed the famed Mohawk steelworkers who had been working on San Francisco's Golden Gate Bridge, which would be completed in early 1937. The lower level work was also important, with the building of 120-foot-deep watertight chambers to allow for the construction of underwater bridge piers.

At the bridge opening on August 6, 1938, a crowd of seventy-five thousand people watched as twenty-two thousand others marched in a two-and-a-half-hour-long parade. Connecticut governor Wilbur Cross (who several years later would have the Wilbur Cross Parkway named for him) cut the blue ribbon and gave the main address.

Construction of the Middletown-Portland Arrigoni Bridge in 1938. It replaced a forty-three-year-old bridge. *Middlesex County Historical Society Collection.*

Years after its opening, the bridge was named after Senator Charles J. Arrigoni of Durham, who served in the Connecticut Senate from 1937 to 1940 and the Connecticut General Assembly from 1933 to 1936. Arrigoni had helped to spearhead the efforts to replace the old, inadequate bridge.

The Arrigoni Bridge has two six-hundred-foot steel arches, which have the longest span length of any bridge in Connecticut. The bridge, with its roadway suspended from its arches by cables, was designed to provide high clearance (ninety feet) above the water. This eliminated the need for a drawbridge. Today, the Arrigoni Bridge is used by an average of thirty-five thousand vehicles each day.

RELIGION

The Oldest Bell, a Mysterious Grave Marker and the Roman Soldier Saint

At every step in Middlesex County history, the religious faith of its citizens played a prominent role: in serving their God, in serving their fellow men and women and in creating a society that is just and merciful. From the Puritans of the 1600s, to the European Protestants and Catholics of the 1800s, the Jewish immigrants of the late nineteenth and early twentieth centuries and the Latino, Asian, Middle Eastern and other immigrants of today, these devout people built their places of worship, created homes for the poor, contributed to the educational systems and established a moral backbone for the fifteen towns at the lower end of the Connecticut River Valley.

It is believed that the first public religious services in Middletown took place soon after settlement in 1650 under a large elm tree that stood near the entrance to the North Main Street graveyard. Later, services most likely were held in individual homes until a church could be built.

Chester provides a good example of the way many towns in the county— and in the rest of Connecticut—were founded. Chester, originally part of Saybrook, was known as the Pattaquonk Quarter. It received its current name when it was incorporated as a parish in 1740. Before then, and until 1729, residents went to church in Essex. Then an arrangement was made that they could hold servicers in Chester in winter months for four years. The Chester Church was organized in 1742, and the Reverend Jared Harrison was hired as its first minister.

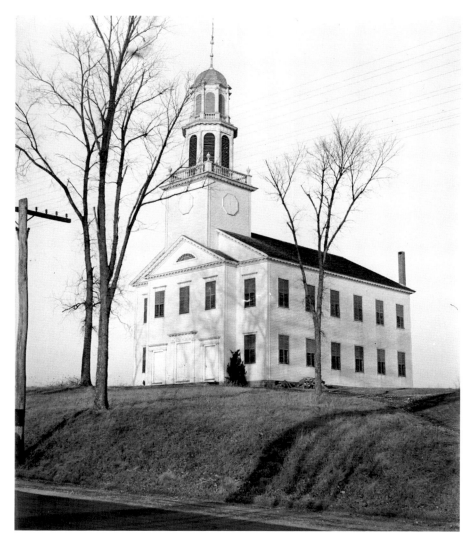

Today's Killingworth Congregational Church building was constructed between 1817 and 1820. It's pictured here in 1895. *Courtesy of the Library of Congress.*

THE OLDEST BELL

St. Stephen's Episcopal Church in East Haddam has one of the oldest objects in the state—and possibly one of the oldest cast bells in the Western Hemisphere. Many believe that the thirty-two-inch-high bell in its bell tower is over 1,200 years old. An old translation of the inscription

on the bell is: "*The Prior being the most Rev. Father Miguel Villa Mueva. The Procurator the most Rev. Father Josi F. Estevan. Corrales has made me. Made in the year A. D. 815.*" That's hundreds of years before Columbus's voyages and perhaps two centuries before Norse explorer Leif Eriksson visited North America.

One legend has it that the bell was salvaged from a Spanish church that was destroyed by Napoleon's troops, and it was seized by the British when they defeated the French emperor. The history of the bell includes the story of how a New England ship captain brought the bell to New York and it was transported by barge up the Connecticut River to St. Stephen's in 1834. Originally, it was hung near what is today the Gelston House. Next, it was moved to the first St. Stephen's and, years later, after a replacement church was erected, to its bell tower. The bell has been in its current location since 1904.

CLINTON STONE

But 1,200-year-old bells aren't the only mysteries that make up Middlesex County church history. Recently, in Clinton, hidden history became apparent when a gravestone was discovered on the grounds of St. Alexis Orthodox Christian Church. In 2017, while moving a two-century-old smokehouse from the property to a permanent home at the Clinton Historical Society, it was discovered that one of the foundation stones was actually a grave marker with the inscription: "In Memory of Mr. Robert Carter Who Died Nov. 7 AD 1751 Age 86 years."

Melissa Josefiak, who in addition to being a St. Alexis parishioner is the director of the Essex Historical Society, recognized from the sharp lettering on the stone that it was preserved from the elements for many decades.

Reverend Steven Hosking of St. Alexis sought to see the stone preserved. It is thought that it might have marked the grave of a Clinton shipwright, Robert Carter, who was buried in nearby Guilford. However, the cemetery on the Guilford town green was discontinued in the nineteenth century, and the stones were moved to new cemeteries without the graves being moved.

ITALIANS AND ST. SEBASTIAN

In 1895, Angelo Magnano moved to Middletown and began working as a barber. A native of the small town of Melilli in southeastern Sicily, Magnano wrote back home to his family and friends encouraging them to move to Middletown. Between 1890 and 1920, the population of Middletown increased from 15,205 to 22,129. Much of that growth consisted of immigrants from Melilli. Most of those families settled on the east side of Main Street, on Green Street, Rapallo Avenue, lower Court Street and Center Street, finding work in the city's fast-growing businesses and factories.

The Melillese brought their traditions with them, and one of the strongest of these was their devotion to Melilli's patron saint Sebastian. He had been a third-century soldier in the Roman emperor's Praetorian Guard and a secret Christian. As they had back home, the Italians annually celebrate their saint's feast day with a parade in which they carry a statue of Sebastian punctured with arrows. (According to tradition, Roman emperor Diocletian ordered him executed with arrows.)

The Saint Sebastian feast includes: Sunday morning Mass, the Nuri runners making their way across town from the cemetery to the church, traditional Italian food, carnival activities, rides and live music. With the original money raised during their feast, along with parishioners donating labor in its construction, the Italian community built St. Sebastian Church (1931–1935) on Washington Street. It is a replica of the village church in Melilli, Sicily. In 1934, the Italians made another permanent mark on the city of Middletown by electing Leo B. Santangelo as its first mayor of Italian descent.

MOUNT SAINT JOHN

In 1904, St. John's Industrial School was founded in West Hartford, Connecticut, by the Xavierian Brothers. Three years later, after land was donated by the Duggan family of Deep River, the organization moved its home and school to its present site along the Connecticut River. The Deep River school opened to residents in 1908. From 1919 to 1958, it was managed by the Sisters of St. Joseph.

In the 1950s, St. John's School's Home for Boys became a full-fledged residential treatment center. When the Diocese of Hartford was broken up

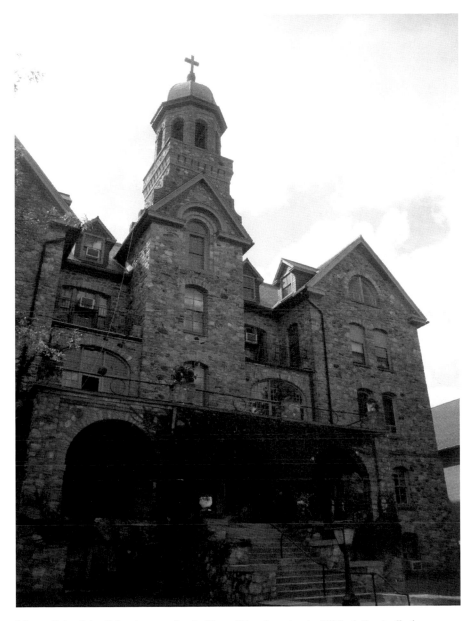

Mount Saint John School opened at its Deep River location in 1908. *Authors' collection.*

into three separate dioceses, the newly created Diocese of Norwich obtained jurisdiction of all Catholic facilities in Middlesex, New London, Tolland and Windham Counties, including St. John's. The diocese expanded the school's facilities and opened up its services to boys from all over Connecticut.

As the modern Mount Saint John notes on its website, the school offers middle school and high school classes for boys and young men, ages eleven to twenty-one, of "all faiths, races, and ethnic backgrounds referred privately or by their local school districts due to behavioral, emotional, and educational challenges requiring specialized education and behavioral health support."

ADATH ISRAEL

In 1902, about forty families formed Middletown's first Jewish congregation. The Connecticut General Assembly approved Congregation Adath Israel's incorporation the following year. Around this time, women of the congregation organized a Ladies Aid Society that prepared bandages for the Middlesex Hospital, raised money for poor farmers and contributed to the needs of the synagogue and the schooling of its children.

After years without a rabbi to lead the services, in the 1920s, an Orthodox rabbi came from the seminary to conduct High Holy Day services. The congregation grew, and in 1929, it constructed a large synagogue at the corner of Broad and Church Streets. About ten years later, it was able to afford a full-time rabbi. Until 1942, all Adath Israel rabbis had been Orthodox. That year, they hired a rabbi of the Conservative movement. Three years later, the congregation voted to change its charter to become a Conservative congregation and eliminate separate seating for men and women.

Today, members of Congregation Adath Israel reside in Middletown, Portland, Cromwell, Haddam, Durham and other surrounding towns. Congregation members Nathan and Shirley Shapiro founded the Adath Israel Judaica Museum. With over 250 items, including a sixteenth-century Czech omer counter and an eighteenth-century Italian ark, it contains one of the largest collections of Judaica in the northeastern United States.

CONGREGATION BETH SHALOM RODFE ZEDEK

In 1915, the Connecticut River Valley's Jewish population founded Congregation Rodfe Zedek in Moodus. Two decades later, the Jewish Community Center of Lower Middlesex County was established in Deep River. In 1998, the two groups merged to become the Reform Congregation Beth Shalom Rodfe Zedek in Chester. As its website states, "We are known as a community of artists and intellectuals as well as farmers, homemakers, businesspeople and professionals." They might have added "famous journalists," as *60 Minutes*' Morley Safer was a member of the congregation. Although familiar to everyone as a result of his forty-six-year career on the CBS television series, he was also known by Chester residents as being down-to-earth and a friend to everyone.

CRIME AND LAW ENFORCEMENT

Gunfighting, Bank Robbing and Selling Liquor to Prisoners

MYSTERIOUS DAVE MATHER

"Mysterious" Dave Mather was born in Saybrook (now Deep River) in 1851. Whether his nickname was derived from his taciturn personality or from his exploits isn't known, but it could just as easily be used to describe the end of his life.

Mather's sea captain father deserted his family a few years after Dave's birth and was murdered aboard his ship in China. In his twenties, Mather went west and became a U.S. deputy marshal in New Mexico Territory and an assistant marshal with the East Las Vegas, New Mexico police force. He knew Wyatt Earp and Bat Masterson well.

After killing two men in separate gunfights as an East Las Vegas lawman, Mather left that town. At various times, Mather was associated with counterfeiting, theft, train robbery and running a brothel. In 1883, he turned up as an assistant city marshal in Dodge City, Kansas, where he owned the Opera House Saloon. The following year, he got into a gunfight with a business rival and killed the man. The next year, Mather shot a man in an argument during a card game. After being arrested, the thirty-four-year-old Mather jumped bail, escaped and disappeared.

Although rumors surfaced that he had either joined the Royal Canadian Mounted Police or been killed by moonshiners in Tennessee, no verifiable information has ever been found on him after 1885.

XYZ

The most famous crime in the history of Deep River was an attempted bank robbery in 1899. The piano key factory had brought such prosperity to the town that it could boast of having two banks: Deep River National Bank and Deep River Savings Bank.

Early in 1913, the American Bankers Association sent two letters to Deep River Savings Bank president Asa Shailer, informing him that its detective agency had discovered a plot to rob his bank. As a precaution, Shailer hired boat builder Harry Tyler to serve as an armed night watchman for the bank building on Main Street. Equipped with a newly purchased Winchester Model 97 riot gun, Tyler waited each night in the bank's dark back room for any signs of trouble. (During World War I, the powerful Model 97 was used by American troops on the western front, prompting the German government to protest its use in combat, claiming it caused "unnecessary suffering." The United States rejected the claim.)

Eleven months later, trouble appeared when Tyler was on guard at the bank. At about 1:00 a.m. on the morning of December 13, 1899, Tyler heard a dog barking and looked outside to see four men clad in dark clothes. Two of the intruders pried open a rear bank window. One of them was carrying a gun. Tyler let loose with his Winchester, killing the gunman on the spot.

The three accomplices quickly made their escape, leaving behind their fallen comrade. With the left half of the man's face gone, a search ensued of his overcoat pockets. There authorities found a revolver, a steel drill, a safety fuse and dynamite cartridges. The dead man was described as about thirty years old, 160 pounds, with a dark complexion and a mustache. For a couple of days, local residents—as well as a Pinkerton detective from New York City—viewed the body, but no one was able (or willing) to identify the would-be robber.

The most promising clue to the man's identity was a money order made out to a Worchester, Massachusetts railroad brakeman named P.E. King, found in the deceased's pocket. King was never located. Ironically, it was later discovered that some of the tools that were used to pry open the bank window were stolen earlier that evening from the night watchman's boat business.

Subsequently, since no one claimed the body, the dead man was buried in a donated plot in nearby Fountain Hill Cemetery. Shortly thereafter, a note was sent to night watchman Tyler in a woman's handwriting. It asked that

Grave of a man who was shot to death while holding up the Deep River Savings Bank in 1899. *Authors' collection.*

a marker with the letters "XYZ" be placed over the grave. Tyler installed a simple wooden marker. In later years, it was replaced by the current stone marker. Who was the woman who made the request? She obviously learned of the dead man's fate either through his fleeing companions or through newspaper reports. And although she allowed his death to remain anonymous, she asked his killer to honor her simple request—to mark his final resting place, where this grave could easily be identified with the XYZ marker. Why?

There's one significant postscript to the story that might answer this last question. After the would-be robber's burial, a woman in a black dress would step off the train at the Essex station on every December 13, walk along the tracks to the cemetery and place flowers next to the XYZ marker. This continued over a span of forty-eight years.

Today, the identities of the dead man, his companions and the woman in black are still unknown. The only physical reminders of the incident are the XYZ cemetery marker and the Model 97 Winchester riot gun. The weapon hangs on the wall of a local bank on the site of the original bank. Also in the display case are the two faded original American Bankers Association letters that warned the bank president of an impending robbery.

COUNTY JAILS

Traditionally, Middlesex County had two superior courts: one in Middletown and the other in Haddam. Similarly, each town had a county jail.

Middletown's first courthouse and jail buildings were built in 1786. The jail was a wooden building on the Washington Street Green. A replacement jail was also a wooden structure, located on a fifty-five- by ninety-five-foot lot on the east side of Broad Street between College and Court Streets. It was used from about 1817 to 1847. A third jail, a forty-four- by twenty-six-foot structure, was built of stone in 1848 for $3,300. It contained twelve cells. The Town of Middletown donated the land for it in southwest part of town.

The first Haddam county jail, a wooden structure built in the late eighteenth century, was located in what is now a parking lot immediately south of the present granite jail. It was superseded by the current jail building, which is located on the corner of Route 154 and Jail Hill Road. It is the oldest county jail in the United States, as well as the first agricultural jail in the country. Built in 1845 with stone from local quarries, its imposing, gray granite walls are two feet thick, and the interior consists of two tiers of cells.

The Haddam jail's mansard-roofed addition was constructed onto the north side of the building in 1876 to house women prisoners. Its upper floor was used as the living quarters for the sheriff's family. Although the Haddam jail held prisoners charged with more serious offenses than the Middletown jail, the overwhelming majority of its population consisted of people brought in on charges of breach of peace, vagrancy, drunkenness, petty theft, unpaid debts and mental illness. It was also known as a working jail where prisoners would labor in nearby unfenced vegetable gardens and milk cows. Before the Haddam jail closed in 1969, it mostly held prisoners with ninety-day sentences.

Usually, prisoners convicted of the most serious crimes were not permanently confined in the Middletown and Haddam jails but rather sent to the Connecticut state prisons: Newgate Prison in East Granby (1773–1827), Wethersfield State Prison (1827–1963) and Somers State Prison (1962–1994). Still, over its long history, the Haddam jail held a number of dangerous prisoners. One of these, Emil Schutte, was convicted in 1922 of killing three of his neighbors before burning down their house. He was hanged "a few weeks later."

After the Haddam jail closed, the building was used as a training center by the State of Connecticut Department of Corrections and, for a limited time, open to tourists.

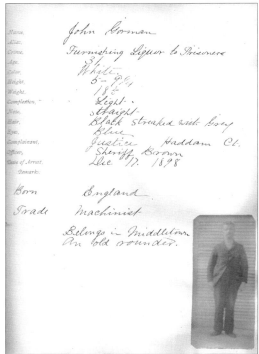

Above: Haddam Jail was built with locally quarried granite. The walls are two feet thick along the cells and fifteen inches thick elsewhere. *Authors' collection.*

Left: Haddam Jail record of John Gorman, who was arrested on December 17, 1898, for "furnishing liquor to prisoners." *Middlesex County Historical Society Collection.*

PAMECHA JAIL

The 1850 brick Pamecha Jail still sits on Warwick Street in Middletown. Nearby is the 1814 Middletown Alms House, which is the oldest remaining building in Connecticut dedicated to providing shelter for the poor. In 2016, the former jail opened as an Italian restaurant with the appropriate name Bread and Water. One of the three dining rooms includes a small room that once served as one of the jail's twelve cells.

A few statistics from the early twentieth century will serve to illustrate the Middlesex County jails' prisoners and the expenses associated with their confinement:

On June 30, 1904, 24 people were housed in Middlesex County jails. Fifteen months later, that figure rose to 30. The numbers seem small, but given that sentences were short, it also meant that during that period 215 people were sent to these jails and 209 were discharged. Of the 215 incarcerated, 11 were female, 11 were males under twenty-one years old, and 74 were former prisoners. The most common offense was drunkenness, with 112 cases; assault came in a distant second with 19 cases. Interestingly, for the same period, Hartford—with four times the population of Middletown—had 15 times as many cases of arrests for drunkenness. With this level of alcohol abuse, it's not surprising the United States adopted Prohibition fifteen years later.

The 1914–15 Middlesex County jail statistics show one person was charged with horse theft, one with keeping a house of ill fame, one with frequenting a house of ill fame and two with begetting an illegitimate child.

For the fifteen months ending on September 30, 1905, $2,424 was paid for jailhouse provisions, $134 for clothing, $37 for bedding and $262 for medical care. Fuel for two years was $743. Salaries were $840 for the jailer and a total of $1,275 for three assistants. The chaplain received $50 over the course of two years. Middletown's Pamecha Jail telephone cost a total of $6 for the fifteen months—or a whopping $0.40 a month.

TERRORISTS IN CENTERBROOK

White Caps were vigilante societies that operated in the United States in the late 1800s and early 1900s. Like the Ku Klux Klan, their members hid

their identities and usually attacked their victims at night. White Caps in the southern United States consisted mostly of lower-income white farmers, and their targets were often African Americans. Their object was often to drive the blacks from their homes; the methods used ranged from verbal and written threats to beatings, whippings and even murders. In the northern states, the targets were often white as well as black.

The Essex village of Centerbrook was the scene of one attack on August 15, 1900. Thirty-four-year-old Madaline Doane was walking along a railroad track with twenty-year-old Italian immigrant Antonio Cutone. A news report at the time stated they had often taken such walks and had "the entire consent" of the woman's thirty-nine-year-old husband, Robert. Apparently, the local group of White Caps thought the friendship was inappropriate and was determined to intervene.

As Doane and Cutone walked along the track, ten men in masks jumped from the bushes and approached them with whips. Cutone ran away, but Madaline Doane was grabbed, a sack was thrown over her and she was beaten. Later, she found a soft hat, a whip and a mask at the scene of the struggle. She said that she recognized some of her attackers.

The next day, Madaline Doane attacked and horsewhipped Joseph Standard, who had an apartment in the same house as the Doanes. Robert Doane had to restrain his wife. Later, Madaline went into Essex and bought a gun. A newspaper article at the time said Cutone was ordered to leave town in six days, but it didn't say if it was the authorities or the White Caps who had issued the demand. Word spread that the White Caps had planned on tarring and feathering Cutone the night of the attack. Apparently, Cutone stayed in town, as his name appears as a town resident in the federal census ten years later. Robert and Madaline Doane were listed as living together in Essex twenty years later.

Ku Klux Klan

While the activities of the Ku Klux Klan are well known in the southern states of America, its activities in the northeastern states during the early twentieth century are surprising for many people. In the summer of 1922, a mass meeting took place on Middletown's South Green to protest recent activities of the Klan in nearby towns; protestors included Middletown's mayor, religious leaders and average citizens of Middletown.

The Middletown assembly followed a recent condemnation of the Klan by the Veterans of Foreign Wars chapter in neighboring Meriden and a mass meeting in Hartford arranged by the Jewish fraternal group, Independent Order Brith Sholom. One of the latter's anti-Klan resolutions stated: "Whereas, an insidious organization is now growing throughout the United States, threatening the social, political and religious life of the nation; an organization with an avowed program to bring physical harm to certain elements of the American people who happen to differ with them in origin, religion and color."

9

ENTERTAINMENT

Sherlock Holmes, Canned Huckleberries and Children Deputies

Many forms of entertainment in Middlesex County have provided guests and residents with a relaxing break from their normal routines. Some rural businesses enticed summering guests into spending their family vacations at their resorts, which offered swimming, canoeing, horseback riding or competitive games like shuffleboard or horseshoes. The relaxing, cool, rural settings were especially popular prior to the larger Disneyesque venues of today. Additionally, entertainment could be found during the summer and fall at local county fairs, 4-H or agricultural grange events, athletic competitions and theaters. This chapter focuses on a few of these places, and it highlights some of the legendary performers who entertained us—both those visiting the county's towns and those who settled here permanently.

One of the oldest forms of entertainment in New England is the county fair, where locals showed off their produce and animals. Today's fairs still bring in crowds who watch the animal pulls, compete in or view the judging of its many events, admire the ribbon winners and enjoy the sights, sounds and, of course, the food. Today, the Association of Connecticut Fairs identifies four Middlesex County fairs as major fairs: the Chester, Haddam Neck, Durham and Portland Fairs.

CHESTER FAIR

The Chester Fair was started in 1877 by the Agricultural and Mechanical Society of Chester, and it has been held continuously except for 1905 and three years during World War II. In 1891, fifty farmers joined the Chester Fair Pumpkin Club and attempted to raise the largest pumpkin in town. Today, pumpkin contests are a common feature of many Connecticut agricultural fairs. Fruit and vegetable preserves were popular with some 1914 Chester Fair first-place winners, including Mrs. Williams with crabapple jelly, Mrs. Clark with canned huckleberries and Mrs. Watrous with canned yellow tomatoes.

Around 1900, a tug-of-war was a popular event at the Chester Fair, with a team from Deep River often vying with a home team for the winner's trophy. Another annual tradition was the fair parade; at its conclusion, prizes would be awarded for the best trimmed floats, wagons, cars and even bicycles.

Still, the staples of the fair were always the displays of farm produce and livestock, as well as the oxen and horse pulls. Plays were presented in the evenings.

HADDAM NECK FAIR

In 1910, the Haddam Neck Fair started with a small fair sponsored by the Haddam Neck Grange. The following year, the grange bought three acres of land and built a new thirty-three- by forty-eight-foot Grange Hall. The first floor was used for the fair dinners, while the second accommodated the fruit and vegetable displays. After the 1911 fair, one news reporter remarked that the corn on exhibit looked like the beanstalk in the Jack and the Beanstalk fairy tale, as "it reached so high that the owner had to take a stepladder to pick the ears."

The first fair attracted 1,500 visitors. In pre–World War II years, live entertainment, new athletic events and a baby show were added. With the arrival of the 1940s and 1950s, children's rides were included, and farm equipment was displayed. Today, the Haddam Neck Fair attracts thousands of visitors throughout Connecticut and beyond. For three and a half days, shows, rides, food, displays and exhibits delight local residents and their guests.

Durham Fair

In 1916, the Town of Durham held its first agricultural fair in fifty years, hosting about 2,000 people. It became an annual tradition, attracting visitors throughout Connecticut and the neighboring states. Today, the four-day-long event is the most popular country fair in the state, with nearly a quarter of a million people attending each September. That is a remarkable number when you consider the population of the town is only about 7,400.

The early twentieth-century Durham Fairs included flower, fruit and vegetable exhibits, cattle shows, horse pulls and band concerts. On May 12, 1957, one of the largest crowds ever to gather in Durham welcomed television's Wyatt Earp—Hugh O'Brian—to the Durham Fair Grounds. He gave an exhibition of gun drawing and sharpshooting as part of the Connecticut Horsemen's annual horse show. The twenty-first-century Durham fairs have featured concerts by such entertainers as the Oak Ridge Boys, Blake Shelton, Foreigner and Pat Benatar.

For the first few years, the fair opened with a parade down Main Street, ending at the town green. Today, there's no longer a parade, but the green has been supplemented with about forty-five acres jam-packed with agricultural exhibits; livestock buildings; horse, pony, oxen and tractor pulls; and midway attractions. Two things remain the same: the fair is still run mostly by volunteers (currently around 100 regular and 1,700 during fair days), and a great time is had by all.

Gillette Castle

Actor William Gillette became famous and wealthy by portraying fictional detective Sherlock Holmes on stage in 1,300 performances between 1899 and 1932 and on the silent movie screen. Two years after Gillette's 1937 death, Basil Rathbone portrayed Holmes in *The Adventures of Sherlock Holmes*. The film's opening credits state: "Based on the play *Sherlock Holmes* by William Gillette."

Gillette used his wealth to realize his childhood dreams. Today, a product of that dream, East Haddam's Gillette Castle, is one of Connecticut's top tourist attractions. Built on 184 acres on the southernmost hilltop of a chain known as the Seven Sisters, the building provides a commanding view of the Connecticut River.

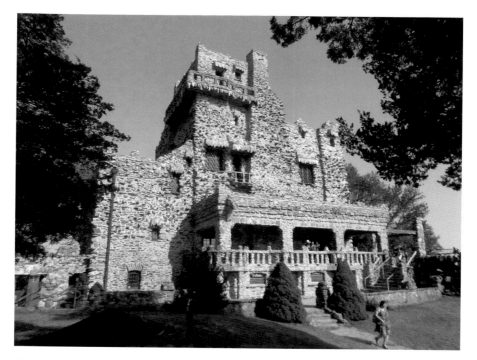

Stage and screen actor William Gillette's home sits high above the Connecticut River in Gillette Castle State Park in East Haddam. *Authors' collection.*

Gillette began the ambitious design of his castle, its grounds and a private railway as he lived aboard his houseboat, the *Aunt Polly*. Modeled after a medieval castle, Gillette's home was constructed of local fieldstone on a steel framework between 1914 and 1919. In the 1920s and 1930s, Gillette's guests usually arrived by boat at his pier on the Connecticut River and then were transported up the hill to his residence by first his steam train and later by his electric train. It delighted his celebrity guests such as Albert Einstein, Calvin Coolidge, Helen Hayes and Charlie Chaplin.

As William Gillette had no children, he was very jealous of his estate, specifying in his will that his castle and miniature railroad not fall into the hands of "some blithering saphead with no conception of where he is or with what surrounded." The will also gave Yukitaka Ozaki, who was his Japanese secretary, butler, valet and friend, lifetime use of a small house he had lived in for years and its surrounding property.

A quiet, unassuming man, Ozaki had never mentioned to Gillette that he was the brother of Yukio Ozaki, who was a pre–World War II mayor of Tokyo, Japan, and the man who donated the three thousand young cherry

trees to Washington, D.C., that eventually resulted in today's National Cherry Blossom Festival. One day, Gillette saw the mayor's name in a newspaper and remarked to Ozaki that he and the Tokyo politician had the same name. Ozaki turn to his employer and calmly replied, "That's my brother."

Sometime later, the mayor, with his family, came to Connecticut to visit his American brother. Legend has it that Gillette switched places for the visit, pretending that Ozaki owned the castle and he was Ozaki's servant. It's not known if this really happened, but the story fits right in with Gillette's well-known sense of humor.

Since 1943, Gillette Castle has been part of a Connecticut State Park. During the 1970s and 1980s, two Gillette enthusiasts, Don and Betty Grant, were instrumental in furnishing the building with memorabilia. Harold and Theodora Niver, a husband-and-wife team, have portrayed Gillette and his wife, Helen, at the Castle for the past forty years. They are an unexpected treat for the visitors, dressed in period costume, acting as the Gillettes once or twice a week. The Nivers are so comfortable in

Harold Niver playing William Gillette playing Sherlock Holmes next to East Haddam's Gillette Castle. *Courtesy of Harold and Theodora Niver.*

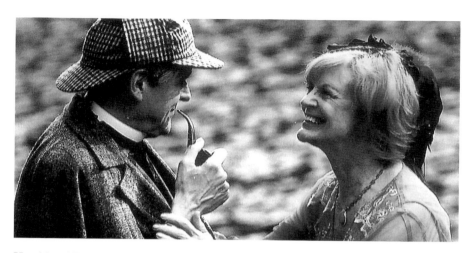

Harold and Theodora Niver, who play William and Helen Gillette at East Haddam's Gillette Castle. *Courtesy of Harold and Theodora Niver.*

their roles, amid the snapped pictures or engaged in answering curious questions, that they consider the Castle their second home. Theodora explained, "They relate to us as the Gillettes. We love it," while Harold remarked, "People come from all over the world—Iceland, Israel, Siberia. They Google Sherlock Holmes and Connecticut, and they see the name William Gillette and the word Castle. Then they want to visit it."

One of the favorite things the Nivers do is to go outside at closing time to the lily pond to wave at cars leaving the castle, just as William and Helen Gillette might have done. Theodora said, "We want to make it a place that they like to visit."

In the 1980s, a Sherlock Holmes group would meet periodically at the Castle. Before each meeting, they were assigned to read a particular Holmes story. Around Halloween one year, they read "The Adventure of the Sussex Vampire." "That evening, just as we were sitting down to dinner," recalled Harold Niver, "we looked up to see a bat, which proceeded to fly across the room. After that, many people asked 'How did you arrange that?'" In the countless times Harold and Theodora have been in the Castle, it was the only time they have ever observed a bat in the building.

YUKITAKA OZAKI

Here's another bit of hidden history regarding the gravestone of Yukitaka Ozaki, Gillette's longtime servant. In 1942, when Yukitaka Ozaki passed away at age seventy-seven, he was buried in Cove Cemetery, which is near the foot of the hill on which Gillette's Castle is perched. Next to Ozaki's gravestone is the grave of Tsubone Fukush, another Japanese employee of William Gillette, who died several years before Ozaki. The other man's stone is marked with his name and some Japanese characters.

Grave of William Gillette's Japanese secretary Yukitaka Ozaki in Hadlyme's Cove Cemetery. *Authors' collection.*

The people who prepared Ozaki's gravestone included his name (misspelled Osaki), the date of his death and the Japanese characters from the other man's stone, probably assuming they were a Japanese prayer or saying. Years later, a Japanese visitor to the cemetery pointed to Ozaki's marker and asked, "Why are there two names on this stone but only one date?" He proceeded to translate the Japanese characters on the top of Ozaki's stone as "the grave of Tsubone Fukush."

GOODSPEED OPERA HOUSE

East Haddam shipbuilder and banker William H. Goodspeed built the Victorian-style Goodspeed Opera House in 1876. The name was a misnomer from the start, as the venue rarely presented anything resembling an opera. It opened in 1877 with a comedy, *Charles II* and the one-act farces *Box and Cox* and *Turn Him Out*. At the time, the only means of crossing the Connecticut River from the west was a ferry; it would be thirty-six years before the East Haddam Bridge would be constructed.

William Goodspeed also built the *State of New York*, which was the largest steamboat to travel the Hartford–to–New York City route. It sank near East Haddam, but it was later raised and renamed the *City of Springfield*.

Goodspeed Opera House's initial heyday ended after William Goodspeed died in 1882. Plays were sporadically presented until a Connecticut militia

Goodspeed Opera House in East Haddam was constructed by shipbuilder and banker William H. Goodspeed in 1876. *Authors' collection.*

unit occupied the building during World War I. It was charged with guarding the adjacent bridge from sabotage attacks. Between 1920 and 1963, the building was used successively as a warehouse and a state highway garage.

In 1940, the building was condemned, and some celebrities, including actress Katharine Hepburn, expressed interest in preserving it by moving it to Hartford or even California. Nothing came of the efforts, but like William Goodspeed's oversized steamboat, his theater was destined to be reborn.

In 1958, Goodspeed Opera House was saved from demolition by the local nonprofit Goodspeed Opera House Foundation with the support of Connecticut governor Abraham Ribicoff, who promised to sell the building to a nonprofit organization for a nominal amount under the condition it would be restored. Ribicoff stated, "This to me is very important for the country's soul. Goodspeed means too much to be neglected, it deserves to be saved....Let us all say godspeed to Goodspeed." Nearly $1 million was collected to restore the structure so it could operate as a theater again. It reopened in 1963 with *Oh, Lady! Lady!!*, a 1918 musical by Jerome Kern, Guy Bolton and P.G. Wodehouse.

Since beginning its second life, Goodspeed has hosted a wide array of musical productions. These included the world premieres of three legendary musicals: *Man of La Mancha* in 1965, *Shenandoah* in 1974 and *Annie* on August 10, 1976.

IVORYTON PLAYHOUSE

In 1930, twenty-nine-year-old Milton Stiefel, one of America's youngest but most famous managers of summer theater productions, opened the Ivoryton Playhouse in Essex, Connecticut. Earlier, he had spotted the unused twenty-year-old building, which had been constructed as an employee recreation hall by the Comstock-Cheney factory. Today, the Ivoryton Playhouse is known as the oldest continuously-running summer theater in the United States.

Between 1930 and 1973, Stiefel produced and directed scores of Playhouse productions and attracted many of the country's top actors. His recruitment efforts paid off, as most productions featured at least one household name, and his theater became known as the "Playhouse of the Stars."

The Ivoryton performers have included Marlon Brando, Carol Channing, Paul Robeson, Ethel Waters, Groucho Marx, Mickey Rooney and local residents Art Carney and Katharine Hepburn. Hepburn, especially, had a fondness for the Playhouse—she debuted there in its first season. Essex

Left: One of the stars who appeared at the Ivoryton Playhouse was singer, actress and *To Tell the Truth* panelist Kitty Carlisle. *Photo given to the authors by Miss Carlisle.*

Below: Ivoryton Playhouse in Essex, which is the oldest continuously running summer theater in the United States. *Authors' collection.*

resident Milton Stiefel passed away in 1983, but his Playhouse continues as an American tradition. Today, the nonprofit Ivoryton Playhouse Foundation has extended its season beyond the summer months to year-round productions with seating for 250 guests.

COWBOY VALLEY

Back in the late 1950s, Connecticut youngsters didn't need to travel to Dodge City, Kansas, or Tombstone, Arizona, to get the feel of the Wild West. From 1957 through 1959 (when television westerns ruled the airwaves), drunken brawls, gunfights and bank robberies took place daily in rural Killingworth, Connecticut. Named Cowboy Valley by its Newington, Connecticut founder, Art DuBois, the twenty-acre site consisted of a saloon, gunsmith's shop, bank, jail, courthouse, trading post and a dozen other buildings built on pastureland. Chief Strong Horse and his nephews, members of the Narragansett tribe, provided a Native American presence.

Young visitors (many bringing their own cowboy hats and cap guns) were given deputy sheriff badges and allowed to help the Cowboy Valley sheriff round up bank robbers. A local man would play the judge and sentence the criminals to leave town and never come back. But they did return, and then they went back to robbing the bank again and again.

Killingworth resident Dan Perkins, who worked at Cowboy Valley in 1958 at age sixteen, remembered that he "rode a horse and robbed the bank every two hours." Between the bank heists, he committed stagecoach robberies. Several times a day, the stagecoach would be held up out of town, and passengers' possessions, including wallets and women's purses, would be taken and returned after everyone got back to town. Perkins remembers that for the first year and a half of Cowboy Valley's existence, he and the other faux holdup men used real, unplugged Sturm Ruger .22 handguns loaded with blanks. Fellow Cowboy Valley employee Marty Machold, who was seventeen at the time, recalled that "there was nothing about the guns to prevent anyone from firing real bullets."

Machold also reminisced about the time Cowboy Valley sent its stagecoach to Hartford for a show, accompanied by "four or five of us on horses." Now seventy-seven years old, he later had a lifelong career as a heavy equipment operator. Looking back to his time at Cowboy Valley, he said, "I got paid to play cowboys, and when I grew up, I got paid to play with big Tonka toys."

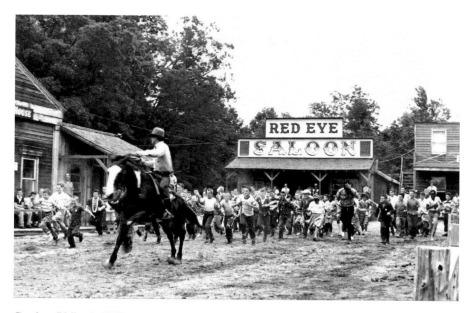

Cowboy Valley in Killingworth in the late 1950s. Consisting of eighteen buildings on twenty acres, it rode the TV western craze, which was then in full swing. *Courtesy of the Killingworth Historical Society.*

Although Cowboy Valley had mostly high school students as employees to help keep expenses down, newer and bigger tourist attractions captured much of Cowboy Valley's business. It closed in 1959. Today, nothing remains of the western buildings, and part of the land is now occupied by the Living Rock Church. However, the memories remain, and in 2017, as part of Killingworth's 350th anniversary, Dan Perkins moderated an evening program on Cowboy Valley at the local middle school. About two-thirds of the five hundred attendees remembered enjoying Cowboy Valley sixty years earlier. At the anniversary parade, Marty Machold rode on the historical society's Cowboy Valley–themed float in his original cowboy gear. "I'm still playing cowboys," he joked.

IT HAPPENED TO JANE (1959)

The movie *It Happened to Jane* was filmed in Chester in the summer of 1958. It stars Doris Day, Jack Lemmon, Ernie Kovacs and almost everyone in town who wanted to be an extra. The film company covered storefronts with

temporary signs, constructed a wooden locomotive and took full advantage of the town's incredibly beautiful waterfront. In 2016, the Chester Historical Society held a walking tour of locations in the center of town that are featured in the film and a discussion by residents of their fifty-eight-year-old memories of the production.

In *It Happened to Jane*, character actor Max Showalter (a.k.a. Casey Adams) plays E&P Railroad board member Selwyn Harris. Showalter became so enamored by the town of Chester that when he retired from acting in 1984, he purchased an eighteenth-century farmhouse in Chester and lived there for the rest of his life. He became active with the Ivoryton Playhouse, the Goodspeed Opera House and National Theatre of the Deaf. Showalter was a veteran of hundreds of television roles from the 1940s through the 1980s in such series as *The Loretta Young Show*, *The Twilight Zone*, *Perry Mason* and *The New Phil Silvers Show*. Showalter's forty-plus movie roles include costarring with Marilyn Monroe in her films *Niagara* and *Bus Stop*. He died in Middlesex Memorial Hospital in 2000 at age eighty-three.

THE BULLDOGS OF THE TRAIL

It Happened to Jane wasn't the first movie to be filmed in Middlesex County. Back in 1915, a concern called the Interstate Feature Film Company spent the month of January in Portland and Middletown filming *The Bulldogs of the Trail*, which is a story of the Royal Canadian Mounted Police.

One exciting scene was shot on February 4, when they filmed a car speeding across railroad tracks. Although the car just made it before a locomotive passed, the cars behind were forced to stop their chase. Later in the day, another exciting scene was filmed with a car dashing off the embankment of one of Portland's brownstone quarries.

The film's male lead, Kenneth MacDougall, wrote, directed, and produced the movie. It also stars twenty-six-year-old stage actress Sidney Shields. Apparently, after completing *Bulldogs* and one other silent film in 1915, Shields decided to return to stage acting.

LET'S SCARE JESSICA TO DEATH

Another movie filmed in Middlesex County was the 1971 horror film *Let's Scare Jessica to Death*, starring Zohra Lampert in the title role. The plot involves a mentally disturbed woman who moves into the Old Bishop House, a supposedly haunted farmhouse. The building used was a large hilltop Victorian-style house on Middlesex Turnpike in Old Saybrook. Other filming locations were in Chester, East Haddam and Essex. Chester's scenes included the Chester-Hadlyme Ferry, Carini's hardware store, the Pattaconk Reservoir and Jennings Pond. East Haddam's First Church Cemetery appears in a few places, and the E.E. Dickinson Mansion in Essex was used for some interior scenes.

Although film critic Leonard Maltin only gave the movie two and a half stars out of four, it went on to become a cult classic. Over the course of the past twenty years, visitors at the popular movie website IMDb have given it a respectable six and a half stars rating across all age groups.

The Old Bishop House that was used in the movie *Let's Scare Jessica to Death* is located on Middlesex Turnpike (Route 154) in Old Saybrook. *Authors' collection.*

BILL HAHN'S HOTEL

In the mid-twentieth century, Westbrook was sometimes called the "Catskills of Connecticut" due to the presence of Bill Hahn's Hotel resort on Stannard Beach. The resort was especially popular with New York City Jewish families, who left the city during the hot summer months and made the easy commute by train.

In 1941, after working as the manager of another local hotel, twenty-nine-year-old Bill Hahn opened his resort. With the help of his sister, Ruth Hahn Richter, he turned it into one of New England's most popular resorts, offering an inviting beach, social activities, great food and even greater entertainment, which included comedy acts and musical shows. In all, the luxurious accommodations consisted of thirteen Victorian buildings filled with antiques.

Almost as famous as Hahn's showmanship was his generosity—especially with his large donations to the American Cancer Society, for which he was recognized as having the largest fundraiser in Connecticut. Every year on his birthday, Hahn would invite the biggest stars to perform at his party. Next to each attendee's place setting would be an empty envelope with instructions to fill it with a donation to the American Cancer Society. At Hahn's fiftieth

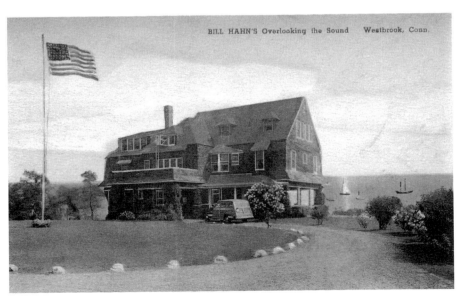

The hotel in Westbrook that was owned and operated by showman and philanthropist Bill Hahn. *Courtesy of the Westbrook Historical Society.*

birthday show, performers included Barbra Streisand, Art Carney and Henny Youngman. Some of the other stars who performed were Goldie Hawn, Eartha Kitt and Woody Allen.

One waiter told the *Hartford Courant* after Hahn's death that "Bill Hahn knew we were just young boys and that we'd drop trays, that kind of stuff—stuff you'd get fired for someplace else, but he really didn't have the heart." The resort closed after the deaths of Bill Hahn in 1979 and his sister a year later. The property was later sold and turned into a time-share resort, Water's Edge.

BANNER LODGE

Jack Banner was the owner of one of Moodus's most popular resorts, Banner Lodge, from the 1930s to the 1970s. Utilizing the land that had been his father's dairy farm in 1922, Jack Banner expanded his establishment into a 322-acre complex with New England's largest outdoor swimming pool.

One Banner Lodge ad from the 1950s–60s era enumerated some of its activities: dancing, tennis, handball, softball, badminton, boating, horseshoes, archery, swimming, camp fires, group singing, beauty contests, gala shows and "belly laughs." His lodge would have something for everyone if they vacationed with him—and many returned every year—first enjoying the partying singles scene but later returning to bring their families as they enjoyed golf, farm-fresh food, outings in the country air, rest and relaxation in this pastoral setting.

There were three stages at Banner Lodge, with the main playhouse, seating about five hundred people, built in the 1940s. It hosted popular bands, singers, comedians and dancers all the way through the 1960s. Some of the celebrities who stayed at his resort were actor Buddy Ebsen, Elston Howard (the first African American to play for the New York Yankees) and comedy actor Zero Mostel, who was Banner's first cousin. When Mostel was suffering hard times, Banner gave him summer work entertaining at his resort, and later, when Zero became a top star, he would come to Moodus to do shows for his cousin.

Jack Banner was also a member of the Connecticut House of Representatives, where he worked hard to preserve the state's historical sites, including the Goodspeed Opera House, which had been used for years as a state Department of Transportation garage. Jack Banner died in 1979 at age seventy-five.

SPORTS

The Sons of Italy and the Oldest Major Leaguer

I ncredible athletes representing all sports have been born in Middlesex County towns, played on its high school teams and gone on to fantastic collegiate and professional careers. Some of the greatest include Marshall "Major" Taylor, the late nineteenth-century/early twentieth-century bicyclist who in 1899 won the one-mile sprint, becoming the second African American to win a world sports championship; and prizefighter Willie Pep, who began his career as an amateur in 1937 and fought his last professional match in 1966. Pep had a career record of 229-11-1 and is usually rated one of the greatest boxers in the history of the sport.

Recently, Killingworth-raised, Middletown-educated Jeff Bagwell was inducted into the National Baseball Hall of Fame in Cooperstown, New York. Here is his story, as well as the tales of several other outstanding athletes.

JEFF BAGWELL, HALL OF FAMER

Jeff Bagwell moved to Killingworth when he was only one year old. Years later, he became an athletic sensation when playing soccer, basketball and baseball at Middletown's Xavier High School. But it wasn't until he played for University of Hartford coach Bill Denehy, a former major league pitcher and Middletown native, that Bagwell found his calling. After being picked up by the Boston Red Sox, Bagwell was traded to the

Baseball signed by Jeff Bagwell, a former Xavier High School player, Houston Astros first baseman and National Baseball Hall of Famer. *Courtesy of Deborah Shapiro.*

Houston Astros for a thirty-seven-year-old pitcher. It's generally considered one of the worst trades in baseball history, as only a year later, Bagwell was named the 1991 National League Rookie of the Year and went on to play fifteen incredibly successful years as an Astros first baseman.

In 2001, Bagwell became only the sixth player in history to accumulate at least 30 home runs, 100 runs scored and 100 RBIs per year for at least six consecutive years. When he finished his last season in 2005, he had a .297 batting average, 449 home runs and 1,529 RBIs. He also stole 202 bases, which was the most by a first baseman since 1920. In 2017, he was enshrined into the National Baseball Hall of Fame in Cooperstown, New York. In his acceptance speech, he remembered his parents: "Mom…you've been a pillar for me. I can't tell you how much I love you.…My father…brought me to love this game of baseball. Something my father instilled in me was to never quit."

Paul Hopkins, Major Leaguer

Beginning his pitching career with Chester High School's title win over Deep River in 1921, Chester native Paul Hopkins later pitched for Colgate University and the Middlesex County League. His talent did not go unrecognized, as the Washington Senators offered him a contract in 1927.

On his first day in the major leagues, twenty-three-year-old relief pitcher Hopkins faced baseball's most famous slugger, Babe Ruth. It was September 29, 1927, at Yankee Stadium, the all-time, single-season home-run record was fifty-nine, and "The Babe" had already chalked up fifty-eight homers. In the fifth inning, with the bases loaded, Hopkins walked to the pitcher's mound and, for the first time, saw who he would be facing. After a count of two strikes and three balls, Ruth hit his fifty-ninth off Hopkins. The following day, Ruth would hit number sixty, establishing a

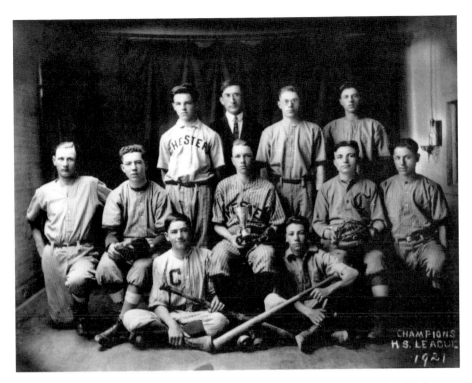

Chester High School baseball team of 1921, with Paul Hopkins holding the local high school league's Bates Cup trophy. *Courtesy of the Chester Historical Society.*

record that would stand until another Yankee, Roger Maris, hit sixty-one homers in the 1961 season.

Paul Hopkins would only pitch another ten major league games before an arm injury ended his career. Later, returning to Connecticut, he became an executive with Shawmut Bank; Hopkins lived out his last years in Deep River. He celebrated his ninety-ninth birthday with the students at Old Saybrook's Middle School, happily giving good advice and signing free autographs. (Hopkins never charged for his signature.) He died the following year in Middletown's Middlesex Memorial Hospital. He made one other mark in the history books: when he passed away in 2004, he was the oldest living former major league player.

STACIA "SKEETS" GAYESKI, BASKETBALL STAR

In 1933, after graduating from Middletown High School, where she excelled in basketball, softball and bowling, Stacia "Skeets" Gayeski was a star offensive player on the Jack's Lunch "Speed Girls" semi-pro basketball team from 1934 through 1941. She was inducted into the Middletown Sports Hall of Fame in 2005.

In the decades following Gayeski's time, Middletown High School continued to produce great basketball players. One of the best was Laurie Boyce. In the late 1970s, she helped create Middletown High School's first modern girls' basketball program. From a record thirty-six-point-game in her freshman year to reaching a career one thousand points in her senior year, Boyce was a star. For three years (1976, 1977 and 1978), she was named to the All-Northwest Conference team. She has been called the girls' team's answer to Middletown legend Corny Thompson. Boyce was inducted into the Middletown Sports Hall of Fame in 2009 and passed away in 2017.

The 1948 East Hampton girls' softball team. In the 1970s, the town's Recreation Department sponsored both men and women softball tournaments. *Middlesex County Historical Society Collection.*

WILBUR J. POPE, BASKETBALL STAR

One of Middletown High School's all-time top basketball players and three-time All-State, Wilbur Pope led the team to state championships in 1968 and 1969. His 1969 team was the first unbeaten Middletown High team in sixty-five years. When he was playing, MHS achieved a record of seventy-nine wins with only ten losses. Wilbur Pope was inducted into the Middletown Sports Hall of Fame in 2008.

JORDAN RUSSOLILLO, SOCCER GREAT

Jordan Russolillo, one of Middletown High School's greatest soccer stars, was All-Conference three times, All-State three times and All-New England twice. At Southern Connecticut State University, he was a three-time All American and was named Connecticut Collegiate Player of the Year in his senior year. Drafted by Major League Soccer's Chicago Fire, he played in 2006 and 2007, until an injury ended his career. He was inducted into the Middletown Sports Hall of Fame in 2009.

JOEY LOGANO: OFF TO A FAST START

Born in Middletown, Joey Logano was a student at St. John's Elementary School in Middletown. Joey's grandfather Sal Logano; his father, Tom Logano; and his uncle, Robert Logano, have been inducted into the Portland

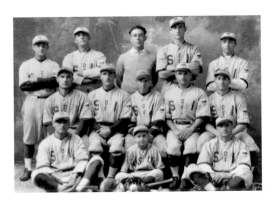

Middletown's 1923 Sons of Italy baseball team. The Sons of Italy (or Figli d'Italia) was organized as a mutual aid society in 1902. *Courtesy of Middletown Sports Hall of Fame.*

(Connecticut) Sports Hall of Fame. Joey and his family moved to Georgia when he was ten years old.

Joey Logano became the youngest professional stock car racing driver to win a nationwide series race when he won the Meijer 300 race at Kentucky Speedway. It was 2008, and Logano had celebrated his eighteenth birthday just days before. The following year, his win at the Lenox Industrial Tools 301 at New Hampshire Motor Speedway made him the youngest Sprint Cup winner in history.

LEO KANIA

Middletown native Leo Kania starred in basketball and track at Woodrow Wilson High School in the late 1930s and early 1940s. In 1941–42, he was the Connecticut State shot put and discus throwing champion. He was also captain of Wilson's undefeated 1941–42 basketball team.

In early 1943, Kania enlisted in the U.S. Army and was assigned to the 110th Anti-Aircraft Artillery Battalion. He was with it when it landed at Omaha Beach on D-day and when Germany made its last major attack at the Battle of the Bulge. After Germany's surrender, Kania was assigned to guard Nazi SS officers.

After retiring as a teacher from the Portland and Middletown School systems, where he also coached track and basketball at Portland High and track at Woodrow Wilson, Kania became a school administrator for the Meriden School system and a guest lecturer on World War II at the college level. A proud member of Middletown's Polish community, Kania was a lifelong member of St. Mary of Czestochowa Church, president of the St. Kazimierz Society, president of the Polish National Home and a member of the Polish Falcons. He passed away at age ninety-three in 2017.

Art and Literature

Dr. Dolittle, Dr. Seuss and the Man on a Hog

What do Horton the Elephant, Babar the Elephant and Eric the Elephant have in common? They're all elephants? Well, yes, but they also appear in stories written by Middlesex County authors. Three of the greatest writers of children's literature have lived in the county: Hugh Lofting, the creator of the Dr. Dolittle stories; Theodor Seuss Geisel, who is better known as Dr. Seuss; and Laurent de Brunhoff, who has been writing the Babar books since 1946. But let's start this chapter on the county's most famous artists and writers by examining the life of a nineteenth-century woman who introduced many people to the American West.

Juliette Augusta Magill Kinzie

Novelist and historian Juliette Augusta Magill Kinzie was born in Middletown, Connecticut, in 1806. In 1830, she married John Harris Kinzie, an Indian agent at Fort Winnebago in Michigan Territory, which was a wilderness outpost and is now part of Wisconsin. John Kinzie's father was a pioneer fur trader.

Juliette Magill Kinzie's first work, *Narrative of the Massacre at Chicago*, is an account of the massacre at Fort Dearborn garrison during the War of 1812. Twelve years later, in 1856, she published her most famous work, *Wau-*

Bun: The "Early Day" in the North West, which includes her experiences at Fort Winnebago in the early 1830s. Unlike most books of the day, *Wau-Bun* deals sympathetically with the trials of Native American peoples.

In 1869, she published a novel, *Walter Ogilby*. All of Kinzie's books were incredibly popular and went through numerous reprintings in both the nineteenth and twentieth centuries. One of Juliette's daughters, Eleanor, was the mother of Juliette Gordon Low, the founder of the Girl Scouts in the United States. Juliette Augusta Magill Kinzie died in 1870.

HUGH LOFTING

Born in 1886, Irish-English civil engineer Hugh Lofting was serving on the western front during World War I when he wrote letters to his two children—letters that included stories of a doctor who could talk to animals and heal them. In 1997, on the fiftieth anniversary of Lofting's death, his son Christopher spoke at the Killingworth Public Library, stating, "He was depressed and impressed by the role animals played in the war." After the war, Lofting moved with his family to the United States and wrote most of his ten Dr. Dolittle novels from his home in Killingworth, Connecticut.

Lofting's first book, *The Story of Dr. Dolittle*, was published in July 1920. In the introduction for the tenth printing, English novelist Hugh Walpole stated: "I don't know how Mr. Lofting has done it; I don't suppose that he knows himself. There it is—the first real children's classic since 'Alice.'" In 1923, his book *The Voyages of Doctor Dolittle* won the American Library Association's prestigious Newbery Medal for its contribution to American literature for children. It didn't take long for children throughout the world to know about Polynesia the parrot, Chee-Chee the monkey, Gub-Gub the pig and Dab-Dab the duck.

Like Sir Arthur Conan Doyle before him, Lofting tried to get rid of his fictional hero. He sent him to the moon in 1928's *Dr. Dolittle in the Moon*. Fans insisted on more stories, and Lofting wrote *Dr. Dolittle's Return* in 1933. He died in 1947, having outlived his first two wives. Today he lies buried in Killingworth's Evergreen Cemetery between his second wife, Katherine Harrower (1893–1929), and his third wife, Josephine Fricker (1908–1966).

Twenty years after Hugh Lofting's passing, Hollywood released a major movie musical based on his stories. Rex Harrison stars as the beloved

Dr. Dolittle's creator Hugh Lofting moved to America in 1919 and settled with his family into this house in Killingworth. *Authors' collection.*

character in *Doctor Dolittle*. Years later, Eddie Murphy became the doctor in the comedies *Doctor Dolittle* (1998) and *Dr. Dolittle 2* (2001).

One man who remembers Hugh Lofting is Bion Shepard. In 2017, he told the authors of the time in 1945 that Lofting visited his one-room schoolhouse in Killingworth to read his work to the children. Although only six years old at the time, Shepard still remembers how excited everyone was with the visit.

DR. SEUSS

Theodor Seuss Geisel, adopting the pen name Dr. Seuss, wrote and illustrated forty-four children's books. Many of these, such as *Horton Hears a Who* (1955), *The Cat in the Hat* (1957) and *Green Eggs and Ham* (1960), are among the classics of children's literature. Geisel's *How the Grinch Stole Christmas!* was made into an animated television special narrated by legendary actor Boris Karloff. It became a permanent favorite of millions of children and adults.

Theodor Geisel was born and raised in Springfield, Massachusetts, which today honors him with the Dr. Seuss National Memorial Sculpture Garden and The Amazing World of Dr. Seuss Museum. When he was growing up in the early 1900s, his parents would rent a beach house each summer in Clinton, Connecticut. There, he and his older sister Marnie would build sand castles and go clamming. Geisel died in 1991 at age eighty-seven.

LAURENT DE BRUNHOFF

Another famous children's book author who lived in Middlesex County was French-born Laurent de Brunhoff. His father, Jean de Brunhoff, created books with Babar the Elephant and wrote seven of the books in the 1930s. The character Babar the Elephant was created by Laurent's mother, Cecile, when she amused Laurent and his brother, Matthieu; they were five and four years old, respectively. They told their father, who was an artist, and he created drawings of Babar.

When Jean died in 1937, Laurent finished his last two books and proceeded to write more than three dozen Babar books between 1946 and 2014.

In 1985, Laurent moved from France to the United States and settled near Wesleyan University, where his future wife, author Phyllis Rose, was an English professor. Occasionally, de Brunhoff used Wesleyan in his books. In his *Babar's Little Girl*, for example, he shows the Wesleyan president's home as a villa.

KILLINGWORTH IMAGES

Like Cecile de Brunhoff, Killingworth farmer Clark Coe (1847–1919) designed objects to amuse children in his family. Coe's creations were life-sized mechanical wooden images for his grandchildren. The outdoor display consisted of about forty moveable figures of people and animals that were powered by a water wheel fed by an adjacent brook. The figures were assembled from scraps of wood, used clothes and other materials. They included a mother rocking her child, a bandmaster with his musicians and a Ferris wheel with tiny riders.

Coe's display attracted visitors from throughout New England. He spent long hours improving and maintaining his display, which soon acquired the name "Killingworth Images." Coe eventually decided to post a coin box for donations as well as an accompanying sign-in book. Within about three months, he had over six hundred names, some from as far away as England and France.

After Coe died in Killingworth at age seventy-two, the site was not properly maintained, and it deteriorated. Fortunately, some pieces were stored at the local historical society. Today, about seven or eight of Coe's images survive.

Visitors can see Coe's *Man on a Hog* (circa 1890) at the Smithsonian American Art Museum in Washington, D.C.; it is built of wood, tinned iron, iron nails and textile pieces. Coe's *Musician with Lute* (circa 1900) sits in the American Folk Art Museum in New York City, and his bandmaster is now on display in the Killingworth Library, although the accompanying musicians are long gone.

DICK AND JANE ILLUSTRATOR

Old Saybrook resident Robert B. Childress (1915–1983) was an American illustrator and painter. He was best known for his illustrations in the popular Dick and Jane readers by Scott Foresman and Company. This reading series was published for forty years, teaching reading to approximately 80 percent of first graders across the United States.

Childress helped teach children to read through "whole word" or the "look, say" reading method, which heavily relied on picture clues for what was said on the page. Prior to this method, children were taught reading by phonics, sounding out letters and word parts, but it was unsuccessful in teaching some children, so the "look, say" method of reading was introduced in 1930 and was very successful due in part to publishing high volumes and using cheaper paper so every child could have his or her own reading books.

Robert Childress was hired by Scott Foresman and Company to create a more modern look for the Dick and Jane series. He used his children, wife, neighbors and pets as models for his pictures. After taking photographs, he would draw pencil sketches and then complete his artwork, bringing the characters, settings, and events to life. In 1952, Robert Childress and his wife, Nan, moved to Old Saybrook, which provided him access to New York City through the railroad.

HIDDEN HISTORY OF MIDDLESEX COUNTY, CONNECTICUT

In the 1960s, Childress was commissioned to create a five- by sixteen-foot mural of Old Saybrook Harbor. Originally displayed at the former Middletown Savings Bank building, it can be seen at Old Saybrook's Acton Library. The mural, known as *The Inner Lighthouse at Old Saybrook*, depicts the movement of seagulls and a sailboat off the Old Saybrook coast.

Both Childress and his wife were founding members of the Old Saybrook Historical Society. An original photograph, along with his initial sketch for the Dick and Jane series, is on display at the society's Hart House in Old Saybrook. Additional work by Robert Childress can be found at the Norman Rockwell Museum in Stockbridge, Massachusetts, and a Childress portrait of Kathleen Goodwin can be found at the Old Saybrook elementary school that bares her name.

HEINZ WARNEKE

Artist and modernist sculptor Heinz Warneke was born in Bremen, Germany, in 1895, trained in Europe and immigrated to the United States in 1923. Two years after acquiring American citizenship in 1930, he bought a farm in East Haddam, Connecticut. Although Warneke and his wife, Jessie, would often be away on projects—sometimes for years—they always enjoyed returning to their East Haddam home, which they called The Mowings. There, Warneke often created the sketches and studio models that would precede his large sculptures.

Unknown to most Connecticut residents and visitors, the full-scale model of Heinz Warneke's tympanum of *The Last Supper*, which he created in a barn on his property, is now on display in East Haddam's Historical Society and Museum. Dr. Karl Stofko, East Haddam municipal historian, explained, "The original can be found above the lintel on the South Portal of Washington, D.C.'s National Cathedral." It is seventeen feet tall and weighs 3,600 pounds. Another of Warneke's best-known works, *The Prodigal Son*, is on display in a garden at the cathedral.

Warneke was also one of America's best-known animaliers, an artist (especially a sculptor) who is known for his skill in depicting animals. Especially notable are his Indiana limestone *Nittany Lion* (1942), depicting Pennsylvania State University's mascot; *Wild Boars* at the Smithsonian American Art Museum; and *African Elephant and Calf* at the Philadelphia Zoo.

Dr. Karl Stofko, East Haddam's Municipal and Historical Society historian, stands next to Heinz Warneke's model of his sculpture *The Last Supper and Road to Emmaus. Authors' collection.*

Readers may be surprised to find some hidden history outdoors in East Haddam—at least three of Heinz Warneke's works are on display locally. The bronze sculpture *Moving the Boulder* was cast after Warneke's death and erected in front of East Haddam's Old Town Hall. The Town of Lyme's World War II memorial monument, displaying a large, patriotic eagle, was created by Warneke in the late 1940s from a local granite boulder. The third local Warneke piece is the gravestone of Jessie, his wife of fifty-five years, who passed away in 1982. The image on the stone is of the two of them planting a tree together. Heinz Warneke died a year after his wife.

ROBIN COOK

Many noted writers have attended Middletown's Wesleyan University. Perhaps the Wesleyan graduate with the greatest number of books sold was medical doctor Robin Cook. Specializing in medical thrillers, Cook has seen almost four hundred million copies of his novels sold between 1972 and 2017.

Ten years after he graduated from Wesleyan in 1962 with a bachelor's in premed, Cook's first novel, *Year of the Intern*, was published. Cook has written over thirty other novels on such topics as genetic engineering, organ donation, drug research, research funding and managed care. Born in 1940, Cook was also a graduate of Columbia University College of Physicians and Surgeons and Harvard Medical School.

Decades after his Wesleyan years, one of Cook's roommates told a *New York Times* feature writer that Cook was "one of the most focused students I can remember." In 2017, Cook returned to Middletown for his class's fifty-fifth reunion and spoke at Wesleyan's new R.J. Julia Bookstore. He discussed how his writing has been affected by his experiences at Wesleyan.

INTERESTING PEOPLE

Scientists, Hermits and Heroes

There are many key people in Middlesex County history who did not conveniently fit into the preceding pages. The purpose of this chapter is to catch some of them. They range from a Revolutionary War founding father to Chester's longest-serving town official, from hermits whose names are unknown, to the man who founded the largest general scientific society in the world. They include a world-renowned actress, as well as people who saved the lives of others in the waters off Middlesex County's Long Island Sound towns.

LADY FENWICK

Alice Apsley acquired the honorific "Lady" when she became the wife of her first husband, Sir John Boteler, who later died. In July 1639, she sailed from England with her second husband, George Fenwick. The couple landed at the mouth of the Quinnipiac River in New Haven and traveled east to the Saybrook settlement. George Fenwick brought with them the first seal from England, and its symbol of fifteen vines bearing fruit is now part of Connecticut's state flag. He would later serve as governor of Saye-Brooke (Saybrook) Colony from 1639 to 1644.

Soon after arriving at Saye-Brooke, Lady Fenwick gave birth to a daughter, Elizabeth, and as there wasn't a church in the colony, she traveled to Hartford

for the baptism. Some of Saye-Brooke's prosperity was attributed to Lady Fenwick, as she tried to improve the community by growing and harvesting medicinal herbs and flowers, cultivating fruit trees and raising rabbits. She even had a "shooting gun" for hunting wild game. In 1645, Lady Fenwick died as a result of complications in the birth of her second daughter, Dorothy. Her husband soon left Saybrook Colony for England and never returned.

Lady Alice Fenwick was buried on Tomb Hill near the Connecticut River, close to where she lived near Fort Saybrook. Today, this is in the vicinity of Saybrook Point Inn. Before sailing back to England, George Fenwick entrusted one of the settlers, Matthew Griswold, to care for Lady Fenwick's grave in exchange for several hundred acres in what is now Old Lyme. After the fort was destroyed by a fire the following year, a new one was built nearby, leaving the Fenwick grave alone in an open field.

Because the Fenwicks played a key part in the community's development, in 1899, through a special act of the Connecticut legislature, the Borough of Fenwick was formed, which is now home to wealthy summer residents. The Historic District of Fenwick covers about 195 acres; in 1995, it was added to the National Register of Historic Places. It includes sixty buildings and the Fenwick Golf Course, Connecticut's oldest public golf course, with the original holes laid out in 1894 (holes 5, 6, 7), in 1895 (holes 2, 3, 4) and in 1896 (the remaining 9-hole layout). Today, active-duty U.S. military personnel with proper ID can play nine holes at no charge.

In 1870, with a railroad coming through Saybrook, Lady Fenwick's deeply buried remains were disinterred. Although the casket had disintegrated, her skeleton was intact, minus a joint of one of her little fingers. Instead of curly,

Lady Fenwick's grave in Cypress Cemetery in Old Saybrook. In 1870, her remains were transferred here from her original 1645 grave. *Authors' collection.*

auburn-red hair, as mentioned in some seventeenth-century accounts, it was a "more flaxen" color, which might be attributed to being buried for 220 years. She was reburied across the street at Cypress Hill Cemetery, where her seventeenth-century gravestone can be seen today.

Today, visitors to the Old Saybrook Historical Society can see a lock of Lady Fenwick's hair, given to the society before her body was reinterred. About forty descendants of Matthew Griswold bear the costs to maintain Lady Fenwick's grave site. The last major repairs took place in 2011, when they provided a $3,400 check to both restore the monument and treat it to prevent moss or lichen growth. The Griswold family still has about seventeen homes on the bequeathed property, so descendants, including cousins, weed the gravesite and care for Lady Fenwick's final resting place. They know if the 1645 pledge is broken, their land will be forfeited.

At Lady Fenwick's 1870 reinternment, the Reverend Samuel Hart of Trinity College, an Old Saybrook native, read an 1856 poem by Connecticut historian Frances M. Caulkins. Titled "The Tomb of Lady Fenwick," it includes these lines:

On Saybrook's wave washed height,
The English lady sleeps:
Lonely the tomb, but an angel of light
The door to the sepulcher keeps.

And ever this wave-washed shore
Shall be linked with her tomb and fame,
And blend with the wind and the billowy roar,
The music of her name.

BENJAMIN FRANKLIN AND JARED ELIOT

In 1753, Benjamin Franklin and Virginia's William Hunter were jointly appointed postmaster general for the American colonies. Franklin made several innovations, including the introduction of day and night mail carrying, and the option of a "penny post," whereby letters not picked up at the post office were delivered to homes and businesses for a penny.

It was said that during one inspection trip to New England, Franklin was traveling up the Boston Post Road when his horse veered off the road onto the

property of Jared Eliot. Eliot explained that he once owned the horse, and it just thought it was going back home. This was the start of a long friendship between the two men.

Eliot's friendship with the man who many considered the greatest person of the colonies was not surprising given that Eliot, a Yale graduate, was also a man of many talents. He was a writer who wrote groundbreaking essays on scientific agriculture methods, a physician and the minister of Killingworth's church from 1709 to 1763. Today, Clinton honors him with a school bearing his name—Jared Eliot Middle School—located on Fairy Dell Road.

Benjamin Franklin's original stone mileage marker—now in Clinton's Historical Society's museum room in its town hall building. *Authors' collection.*

In 1763, Franklin traveled 1,600 miles, surveying post roads and post offices from the Virginia colony to New England. In Connecticut, he directed the installation of sandstone markers along the Boston Post Road that displayed the mileage to major cities. They helped both travelers and mail carriers, allowing the latter to accurately determine the distance letters were carried, which at the time determined the amount of postage. The stone in Clinton was marked with a "25" and a "NH," which denoted it was set twenty-five miles from New Haven.

The Clinton marker, which was originally located two houses east of the town hall, was so familiar to everyone that the house behind the marker came to be known as the Milestone House. In the mid-1900s, the marker vanished and was found under some debris. It was reinstalled, this time in front of the town hall. Sometime later, it was hit by a motor vehicle and broken. The two pieces were placed for safekeeping in the Clinton Historical Society's Museum room in the town hall. Repaired in 2003, the original milestone marker still resides in the town hall, while an exact replica is in its original location.

William C. Redfield

William C. Redfield was born in Middletown in 1789. When he was fourteen years old, he was apprenticed to a mechanic in Cromwell, which was then the part of Middletown known as the Upper Houses. During the following years, a local medical doctor, William Tully, became Redfield's mentor. Tully allowed him the use his extensive private library, which sparked Redfield's curiosity.

One of Redfield's great interests was the study of storms; his observations ultimately led to discoveries that had profound effects on meteorology. It started with a storm on September 3, 1821. Redfield saw that the storm came to Middletown from the southeast, but uprooted trees ended up pointing northwest. Shortly afterward, he had occasion to travel seventy miles away to Massachusetts and noticed that the trees there pointed toward southeast, and the storm had come from the northwest.

Redfield published his findings on the rotation of storms in *The Law of Storms*, which for the first time allowed mariners to predict the action of hurricanes. Over the past two centuries, this information has saved the lives of countless people who were caught in storms at sea.

A Renaissance man, Redfield was also a shipbuilder and, in the early 1800s, proposed a network of railroads that would connect the northeastern United States with the Midwest. In 1848, he became the first president of the American Association for the Advancement of Science. Today, with 120,000 members, it is the largest general scientific society in the world. Redfield died in 1857.

Nicholas Noyes

Unfortunately, Reverend Nicholas Noyes did not leave a positive legacy. Born in 1647, he graduated from Harvard in 1667 and served as minister of Haddam for thirteen years. In addition to receiving land for his dwelling, like many small-town pastors, he was paid with wheat, peas, pork and Indian corn. It was after he left Haddam that he became infamous.

In 1683, Noyes was appointed minister of Salem, Massachusetts, and became known for his active persecution of people accused of witchcraft. Some sources say he later repented; others claim he did not. Noyes died in 1717.

One authority on the Salem trials, Charles Wentworth Upham, stated that Noyes "more than any other inhabitant of the town, was responsible for the blood that was shed." At the hanging of eight of the accused, Noyes is reported to have turned to their bodies and said, "What a sad thing it is to see eight firebrands of hell hanging there!"

DURHAM'S TEXAN

The house in which Moses Austin was born in 1761 still sits on Durham, Connecticut's Main Street. It was built by Moses's father, Elias, in about 1745. Moses Austin's parents sent him to the local schoolhouse for an education, but they died before he was sixteen years old. In 1776, Moses moved to Middletown, where one of his brothers loaned him money to open a merchant shop. At age twenty-two, Moses moved to Philadelphia, where he opened a business and met his future wife, Mary Brown.

In 1798, Austin set out for Missouri with the intention of starting a lead-producing business. At his destination, he initiated the construction of a village, which included his house. Apparently, he hadn't forgotten his home

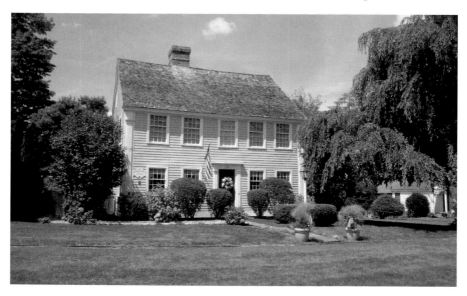

Moses Austin's birthplace on Main Street in Durham. His plan for the settlement of Texas was accomplished by his son Stephen. *Authors' collection.*

back in Middlesex County, as he named the mansion Durham Hall. Austin's mining and retail ventures prospered. Today, he is often credited with founding the lead industry in America.

All was not well during these years, as Austin fought off land claims by French settlers, attacks by Osage warriors and lawsuits by a jealous business rival. Also, drops in the price of lead, as well as problems with his main mine's production, cost Austin dearly. After spending time in jail for not paying off his debts, Austin looked to the next venture—in the Spanish territory called Texas. Using his business connections, he approached the governor and received approval to bring in three hundred Anglo-American families to start a settlement.

Before Moses Austin died in 1821, he turned over the reins of the new settlement to his son Stephen (1793–1836). Stephen continued the work, was a key player in the struggle for Texas independence and was secretary of state for the Republic of Texas. Austin, the capital city of the state of Texas, is named for Stephen. Today, Moses Austin's birthplace of Durham has fewer than eight thousand residents. The city named after his son has close to one million, and Austin is one of the fastest-growing large cities in the United States.

OLD LEATHER MAN

In the late 1800s, several towns in Middlesex County were located along the route of a French-speaking, wandering hermit known as the Old Leather Man. Wearing a homemade sixty-pound suit of leather, this middle-aged man walked a 365-mile circular loop between the Hudson and Connecticut Rivers for over twenty-five years. His "homes" were caves, rock shelters and lean-tos, while his visits to some farmhouses occurred for years on the same day each month. He'd stay outside to eat and would only mumble a few words, like *eat* or *yes*, as he consumed loaves of bread, crackers, coffee and his favorite vice, tobacco—all without answering any questions.

The fifty or so towns that the Leather Man visited included Middletown, Portland and Old Saybrook. It's said that he never harmed a soul in his travels, although he raised his walking stick in a threatening manner if boys assaulted him with stones. In 1889, a year after surviving the blizzard of '88, the Leather Man's body was found in a cave in Mount Pleasant, New York. Blood poisoning from a cancerous tumor on his lip and face was the

Wood and metal pipe fashioned by the Old Leather Man. His passion for tobacco eventually led to his death from lip cancer. *Middlesex County Historical Society Collection.*

coroner's official cause of death. The contents of Leather Man's satchel contained a French prayer book and leatherworking tools—scissors, awls, wedges and a small axe.

In 2011, the contents of the Leather Man's grave in Ossining, New York, were exhumed by Connecticut's state archaeologist in an attempt to locate DNA and establish his identity. Some people guessed he might be a French Canadian from his shoes and prayer book; however, no human remains were found. It was assumed that his body had disintegrated over time so the Leather Man's true identity remains a mystery.

BILLY THE HERMIT

Another Middlesex County loner was Billy the Hermit. For about thirty years at the end of the 1800s, Billy lived in a cabin on the Connecticut River. Located about two miles north of the mouth of the river, it was about one-half mile from Billy's nearest neighbor. No one ever found out Billy's background, although he appeared to be well educated, and a rumor floated around that he had been forced to leave England for some unknown reason. There was no record of him ever receiving mail. As Billy was aways surrounded by dogs, ferrets and hens, during summers, it was common for boaters to cheer him as they drifted by. In response, Billy would stand outside his cabin door and blast his bugle three times.

Like the Leather Man, Billy apparently died from a cancerous tumor, likely caused by smoking. The authorities of Old Saybrook cared for Billy

in his final days. It was supposed that he was over eighty years old. After Billy's death in February 1895, word spread that he had hidden a large treasure, although in life he sold shellfish and ferrets to pay his expenses. People searched every inch of his cabin and the surrounding area to no avail, although many carried away mementos of little value.

Besides his animals, Billy the Hermit had one other hobby: keeping a detailed log of the weather. Every morning, he would climb a bluff near his cabin and, with a spyglass, scan the sky. According to one account, he considered himself a "weather prophet."

Captain George Comer

East Haddam's George Comer was in many ways the opposite of loners like Billy the Hermit. Over the course of his seventy-nine years, Comer was an explorer of both the Arctic and Antarctica; he was also a whaling ship captain, an ethnologist and a cartographer.

Born in Quebec, Canada, in 1858, George Comer grew up in East Haddam, Connecticut. He made his first trip to the Arctic at age seventeen on a whaling expedition, and in his late thirties, he became captain of his own vessel. After fourteen Arctic voyages, Comer was an expert on Inuit culture. Comer established a close friendship with the native people of Hudson Bay. They supplied his crews with caribou meat, fish and warm clothing, and he provided the native people with everything from rifles and knives to cookware and preserved foods.

Forming a friendship far beyond that of other American sea captains, Comer arranged for concerts and social events that would be attended by both ship crew members and the local people. Comer's concern for the Inuit people was ridiculed by some other captains—at least one called him "native crazy."

In the 1890s, Comer established a relationship with the anthropologists at the American Museum of Natural History in New York City, and for the rest of his life, he worked with them in documenting the culture of the Inuit people. This included Comer's handwritten records of Inuit life, photographs, audio recordings and the thousands of objects that he brought back from his voyages.

In 1915, Comer served aboard an American Museum of Natural History rescue ship as it went after men stranded in Donald MacMillan's Crocker

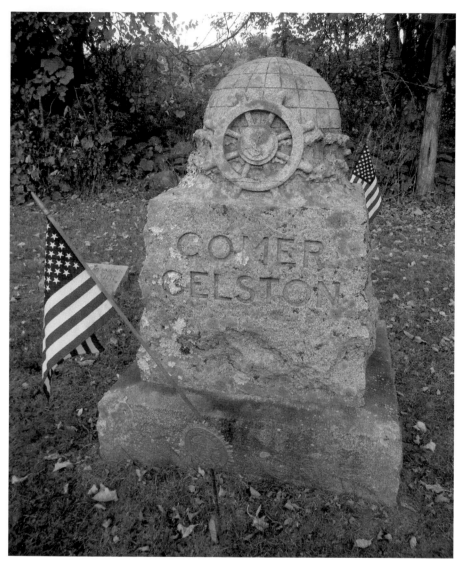

Grave marker of Captain George Comer in East Haddam's Mount Parnassus Burying Ground. *Authors' collection.*

Land Expedition to northwestern Greenland. When Comer's rescue ship was also trapped in ice, he used the two years of waiting time to perform archaeological excavations.

In World War I, Comer, then in his late fifties, served as a navy lieutenant aboard ships that transported troops to Europe. Between 1877 and his

death in 1937, Comer and his wife lived in their home on Mount Parnassus Road in East Haddam—a house that is today occupied by one of his great-grandsons.

In 2017, a weeklong series of events in East Haddam honored Captain Comer with a speech by the curator of collections and oral historian at Mystic Seaport, a talk by a Smithsonian Institution curator and researcher on Inuit art and a rededication of the town's George Comer Memorial State Park.

CONNECTICUT VALLEY HOSPITAL

Many residents of Middlesex County didn't need to survive Arctic expeditions to show their fearlessness. One act of heroism occurred when a patient of the Connecticut Hospital for the Insane (predecessor of today's Connecticut Valley Hospital) rescued fellow inmates. On Christmas Eve 1919, a large farmhouse that used to house patients caught fire. It was located about a mile from the hospital's main buildings.

Only two years before, the hospital experienced its first fatal fire—one in which four patients died. Now, this fire was to prove even more deadly. The morning after the fire, one charred arm was found under debris in the cellar. A thorough search of the smoldering ruins revealed the bones of nine men.

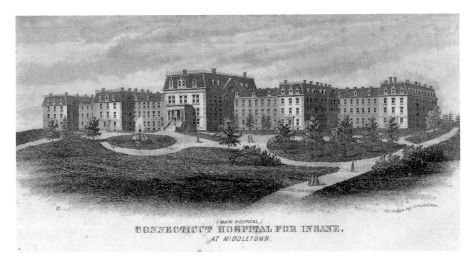

Since its opening in 1868, Middletown's public asylum for mentally ill patients has served thousands of Connecticut residents. *Middlesex County Historical Society Collection.*

Hospital attendant Robert West, who was in charge of the building at the time of the fire, smelled smoke and, upon investigating, found that a pile of wood near the cellar furnace was on fire. West went off to wake the patients in the building who were on the second and third floors. All but one of the dead men were on the third floor. The only one who wasn't had refused to leave the building.

Hospital superintendent Dr. C. Floyd Haviland identified a hero of the fire: forty-five-year-old Haddam resident Fred A. Smith, who had been a patient for five years. Smith made several trips into the burning building to rescue fellow patients, and when all who could be saved were removed, Smith helped put out the flames with the bucket brigade. Once the fire was under control, it was determined that none of the patients had tried to escape from the institution in the confusion.

HEROISM AND RESCUES

There are many more stories of heroism and rescues in Middlesex County history. Here are just a few. On August 28, 1929, twelve-year-old Ann Wilmot of Fales Street, Hartford, was on a float 150 feet away from the Clinton beach when she saw that Hartford medical doctor Mendel Volkenhein was unable to swim to shore. Caught in the strong current, he was exhausted and close to drowning when Wilmot swam to him. Using skills that she had learned at summer camp, she turned him on his back and towed him to shore.

On August 9, 1940, fourteen-year-old Wade Abbott of West Hartford was playing checkers at his parents' summer home near Beach Park, Clinton, when he was alerted that swimmers were in trouble. Dwight Entwisle and his daughter, Dorothy, were caught in a riptide and failing fast. Young Wade jumped up and rowed two hundred yards to rescue the Entwisles. Incredibly, Wade, a student at West Hartford's Kingswood School, was credited with rescuing ten other people at Beach Park that summer. Wade Abbott later served as a staff sergeant with the U.S. Army during World War II and was president of West Hartford's Abbott Ball Company for forty years. He passed away at age sixty-three in 1989.

Another story of Middlesex County heroism occurred in 1970, when a thirteen-year-old boy saved the lives of two men off Old Saybrook's Knollwood Beach. The men were returning from a fishing outing in a

sixteen-foot boat when it sank in fourteen feet of water half a mile from land. The thirteen-year-old, accompanied by another witness, rushed to the drowning men in his twelve-foot aluminum boat. After arriving on land, one of the men was treated for exposure on the scene, while the other was transported to Lawrence and Memorial Hospital in New London.

HARRY RUPPENECKER

It was a very cold February 28, 1970, as the tide was going out and the frigid waters off Westbrook's Pilot's Point were getting choppy. As usual at that time of year, few boats were in the water. Unfortunately, one was: an eight-foot oarless aluminum boat that held two boys, ages six and nine. They huddled on the floor of the boat, which was leaking. A third boy, age fourteen, was in the other boat. He had seen that his friends had been carried out to sea by the winds and tide and had gone after them in a dinghy but was now in peril himself.

A little after 5:00 p.m., the local state police barracks received reports of sightings by residents of two small boats drifting helplessly about two miles from the shore. They called the U.S. Coast Guard, but James Clinton, commander of the Coast Guard Auxiliary in Clinton, had no boats running nearby so he telephoned Harry Ruppenecker of Harry's Marine and Engine Repair. He had a fourteen-foot square-front boat of the kind used to push barges, which had a forty-horsepower outboard. It wasn't something someone would want to use, but, as Ruppenecker remembered, "It was the only thing running."

As Clinton and Ruppenecker, who was also a former U.S. Coastguardsman, were rushing toward the boys, the two in the aluminum boat tossed a cement-filled coffee can overboard, and its thin line caught on some rocks. In a conversation with the authors, Ruppenecker recalled that "we just needed to get out there as quickly as possible," and "it was cold, it was getting choppy and it was getting dark."

Then Ruppenecker and Clinton saw a flash of the setting sun's light off the aluminum boat. After taking the three boys on board, they headed back to Westbrook and were met by a forty-footer sent by the Coast Guard from New London. They transferred their passengers and showed newly arrived Coast Guard vessels the way into the harbor. From the time of the sighting of the boys' boats until their rescue, only about forty-five minutes

had elapsed. Within that time, the boys had drifted about four miles east of Westbrook Harbor.

Today, almost a half-century later, Harry Ruppenecker still owns his marine repair business in Westbrook, which has expanded over the years to include a full-service seventy-six-slip marina on the Patchogue River.

Jim Grote

For someone to be in Chester's first kindergarten class in 1897 and be serving the town in the 1990s is more than a little remarkable, but it's part of the story of James "Jim" Grote. The son of an Italian quarry worker, he served for forty-six years as fire chief of the Chester Hose Company, which he helped create at age twenty-one. He was also its fire marshal for sixty-nine years.

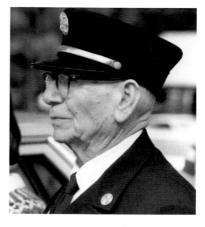

Grote's public service went even further: from 1935 through 1961, he was Chester's postmaster; for forty-six years, he was president of the Agricultural & Mechanical Society (it runs the Chester Fair, which is one of the largest fairs in the state); he was president of the semipro baseball Shoreline League; and he was a town selectman into his nineties.

James Grote, longtime fire chief of the Chester Hose Company, served his community into his nineties. *Courtesy of the Chester Historical Society.*

In his one hundred years, Grote was honored by Pope John XXIII, Ronald Reagan and George H.W. Bush. Connecticut governor William A. O'Neill once remarked, "I'm proud to have known a man who voted for Woodrow Wilson the first time he ran." Grote's funeral in St. Joseph's Catholic Church was presided over by the bishop of Norwich. The January 1992 funeral procession passed under a forty-foot-high arch of crossed aerial ladders sent from Portland and Old Saybrook, and there were twenty-two fire trucks to honor the man who became a local legend.

CBS REPORTERS

We mentioned Chester resident and *60 Minutes* journalist Morley Safer, but he wasn't alone among CBS celebrities in selecting lower Middlesex County as their home. The beautiful, tranquil area, a short distance from the studios in New York City, attracted CBS newscaster Charles Kuralt. Kuralt first bought a home in Essex in the 1970s and later owned a second Essex home until his death in 1997.

Kuralt was best known for his "On the Road" segments on the *CBS Evening News*, during which he would travel around the United States, meeting with ordinary Americans. He was also the first host of the *CBS News Sunday Morning* program. In a tribute after Charles Kuralt's death, his close friend *60 Minutes'* senior producer Phil Scheffler remembered Kuralt's little-used sailboat on the Essex waterfront: "To him it represented some ideal life, and he often sat in the cockpit as the sun dropped below the yardarm, drink in hand, imagining himself, I'm sure, out at sea with only the horizon in front of him."

KATHARINE HEPBURN

Middlesex County has been the home of many famous people over the centuries, including world-renowned celebrities. One of them was actress Katharine Hepburn. One of her favorite places on earth was her beach house in the Old Saybrook borough of Fenwick. Her father, a Hartford doctor, first retreated to the cottage with his family when Kate was about five years old. She considered the cottage her paradise, staying there many times throughout her lifetime.

Originally, the Hepburn home on the Old Saybrook shore was a summer cottage. When the hurricane of 1938 hit, the surprised family escaped from the house just before it floated away. It was replaced by a much larger building, which later provided Katharine with a place to retire. She died at the cottage in 2003 at age ninety-six.

In 1931, Hepburn first performed professionally—at the Ivoryton Playhouse—in the neighboring town of Essex. Over the next half century, she won four Academy Awards for Best Actress, the largest number ever won for this category. As of this writing, no other actress has won as many as three. Hepburn's awards were for the movies *Morning Glory* (1932–33),

Guess Who's Coming to Dinner (1967), *The Lion in Winter* (1968) and *On Golden Pond* (1981). During these years, she was nominated for another eight Best Actress Oscars.

ART CARNEY

One of the great stars of the golden age of television, Art Carney entertained millions with his portrayal of Ed Norton on Jackie Gleason's comedy *The Honeymooners* (1954–56), *The Jackie Gleason Show* (1966–70) and *The Honeymooners* TV specials in the 1970s. In 1974, Carney won the Academy Award for Best Actor for his brilliant performance in *Harry and Tonto*, in which he plays an elderly widower who travels across the United States with his cat. Film critic Roger Ebert stated that his "performance is totally original, all his own."

Born in 1918, Carney served as a U.S. Army infantryman in World War II and received a shrapnel wound that resulted in a lifelong limp. His *Honeymooners* costar Audrey Meadows once described him as "a genuinely nice guy. He hasn't got a nasty, conniving hair on his head." After work in radio, in 1949, he started in television. Comedian Sid Caesar, who did

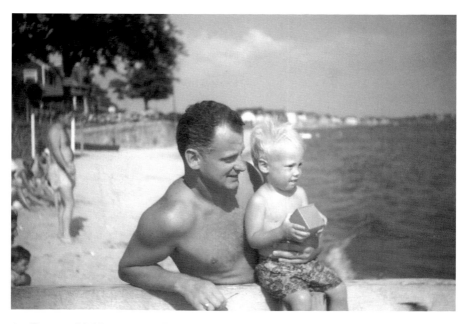

Art Carney with his young son Paul in front of their Westbrook home. Paul later became a noted singer, songwriter and pianist. *Courtesy of Brian Carney.*

Art and Jean Carney's home on the Westbrook beach. *Courtesy of Brian Carney.*

TV specials with Carney, once said, "He was the show, because he was so inventive....I admired him very, very much." In 1954, 1955 and 1956, Carney won the Emmy Award for Best Actor in a Supporting Role. Later, he won four more Emmys, including one for Outstanding Supporting Actor in the TV movie *Terrible Joe Moran*, which was also James Cagney's last role.

In addition to *The Honeymooners*, Carney won critical acclaim for a series of roles in TV dramas, and in 1965, he established the part of Felix Ungar in Neil Simon's smash hit *The Odd Couple*, opposite Walter Matthau's Oscar Madison.

For many years, Carney, his wife, Jean, and their children lived at the beach house they owned in Westbrook. He passed away in Chester, Connecticut, in 2003 at age eighty-five. Jean died in 2012 at age ninety-three. Today, the Carney Awards for "outstanding achievement in character acting" help keep alive Art Carney's name.

Art Carney had a great love for Westbrook. His son, Brian, explained, "To him, it was his own little paradise, and when work called, it was a struggle for him to leave." We are reminded of Judge Constance Baker Motley, who

cherished her forty years in Chester; Katharine Hepburn, who retreated and retired to her family home in Fenwick; and William Gillette, who built his retirement home in the form of a castle high above the Connecticut River. These celebrated individuals, as well as countless less-famous men and women over the centuries, grew to love Middlesex County so much that they chose to call it home.

Bibliography

Books, Motion Pictures and Web Publications

Baldwin, Peter Cunningham. "Italians in Middletown, 1893–1932: The Formation of an Ethnic Community." Honors thesis, Wesleyan University, 1984, https://wesscholar.wesleyan.edu/etd_hon_theses/594.

Beers, J.H. *Commemorative Biographical Record of Middlesex County*. Chicago: J.H. Beers, 1903.

Clouette, Bruce, and Matthew Roth. *Connecticut's Historic Highway Bridges*. Hartford: Connecticut Department of Transportation in Cooperation with the Federal Highway Administration, 1991.

Comer, George, and W. Gillies Ross. *An Arctic Whaling Diary: The Journal of Captain George Comer in Hudson Bay, 1903–1905*. Toronto: University of Toronto Press, 1984.

Conn, Kathe Crowley. *Juliette Kinzie: Frontier Storyteller*. Madison: Wisconsin Historical Society Press, 2015.

Cunningham, Janice P., and Elizabeth A. Warner. *Experiment in Community: An African American Neighborhood, Middletown, Connecticut, 1847–1930*. Middletown: Connecticut Historical Commission, 2002.

Delaney, Edmund. *The Connecticut River, New England's Historic Waterway*. Chester, CT: Globe Pequot Press, 1983.

Donlan, H.F. *The Middletown Tribune Souvenir Edition: An Illustrated and Descriptive Exposition of Middletown, Portland, Cromwell, East Berlin, and Higganum*. N.p.: E.P. Bigelow, 1896.

Durham Historical Society. *Durham, Connecticut*. Charleston, SC: Arcadia Publishing, 1998.

Dwight, Theodore. *History of Connecticut: From the First Settlement to the Present Time*. N.p.: Harper, 1840.

Faude, Wilson H. *Hidden History of Connecticut*. Charleston, SC: The History Press, 2010.

Field, David Dudley. *Statistical Account of the County of Middlesex, in Connecticut*. Middletown: Connecticut Academy of Arts and Sciences, 1819.

Griswold, Wick. *A History of the Connecticut River*. Charleston, SC: The History Press, 2012.

Hancock, John, dir. *Let's Scare Jessica to Death*. 1971.

Hanrahan, Brendan. *Great Day Trips in the Connecticut Valley of the Dinosaurs*. N.p.: Perry Heights Press, 2004.

History of Middlesex County, Connecticut: With Biographical Sketches of Its Prominent Men. N.p.: J.B. Beers & Company, 1884

Hubbard, Robert, and Kathleen Hubbard. *Legendary Locals of Middletown, Connecticut*. Charleston, SC: Arcadia Publishing, 2014.

———. *Middletown*. Charleston, SC: Arcadia Publishing, 2009.

Knowles, William C. *By Gone Days in Ponsett-Haddam, Middlesex County, Connecticut: A Story*. New York, 1914.

The Leading Business Men of Middletown, Portland, Durham and Middlefield. Boston: Mercantile Publishing Company, 1890.

Lefkowitz, Arthur S. *Bushnell's Submarine: The Best Kept Secret of the American Revolution*. New York: Scholastic Nonfiction, 2006.

Lentz, Thomas L. *A Photographic History of Killingworth*. Killingworth, CT: Killingworth Historical Society, 2004.

Lofting, Hugh. *Doctor Dolittle's Garden*. Philadelphia: J.B. Lippincott, 1927.

MacDougall, Kenneth, dir. *The Bulldogs of the Trail*. 1915.

Malcarne, Don, Edith De Forest and Robbi Storms. *Deep River and Ivoryton*. Charleston, SC: Arcadia Publishing, 2002.

Mangan, Gregg. *On This Day in Connecticut History*. Charleston, SC: The History Press, 2015.

Marino, Sebastian. *A Brief Chronology of Events Leading to the Establishment of St. Sebastian Church, Middletown, CT.* Self-published, 1991.

McCain, Diana Ross. *It Happened in Connecticut*. Guilford, CT: Globe Pequot Press, 2008.

McDougall, Robert. *Portland, Connecticut 175th Anniversary Commemorative Book*. Portland, CT: Portland Historical Society, 2016.

Middletown Jewry: Then 'til Now. Middletown, CT: Congregation Adath Israel, 1975.

The Middletown-Portland Bridge: The Story of Its Inception, Pictures of Its Progress, and Its Significance to the Residents of Middlesex County Who, after Many Years of Endeavor Have Seen a Dream Come True. Middletown, CT: Middletown-Portland Bridge Committee, 1938.

Motley, Constance Baker. *Equal Justice under Law: An Autobiography.* New York: Farrar, Straus and Giroux, 1999.

Niles, Hosford Buel. *Old Chimney Stacks of East Haddam, Middlesex County, Connecticut.* N.p.: Lowe & Company, Book and Job Printers, 1887.

Olmsted, Denison. "Address On the Scientific Life and Labors of William C. Redfield, A.M., First President of the American Association for the Advancement of Science," Montreal, Quebec, 1857, https://archive.org/details/9601290.nlm.nih.gov.

Ossad, Steven L., and Don R. Marsh. *Major General Maurice Rose, World War II's Greatest Forgotten Commander.* New York: Taylor Trade Publishing, 2003.

Perkins, Julia, et al. *Long Ago, Not Far Away: An Illustrated History of Six Middlesex County Towns.* Virginia Beach, VA: Donning Co./Publishers, 1996.

Quine, Richard, dir. *It Happened to Jane.* 1959.

Roberts, George S. *Historic Towns of the Connecticut River Valley.* N.p.: Robson & Adee, 1906.

Roberts, Jerry. *The British Raid on Essex: The Forgotten Battle of the War of 1812.* Middletown, CT: Wesleyan University Press, 2014.

Sanford, Elias B. *A History of Connecticut.* Hartford, CT: S.S. Scranton Company, 1888.

Scheffler, Phil. "A Tribute to Charles Kuralt." Remembering Charles Kuralt, www.rememberingcharleskuralt.com/tribute/scheffler.html.

Smith, Venture. *Narrative of the Life and Adventures of Venture: A Native of Africa but Resident above Sixty Years in the United States of America.* N.p.: C. Holt, 1798.

Stevens, Thomas A. *Connecticut River Master Mariners: A Brief Record of Some of the Blue Water Shipmasters of the Connecticut River.* Essex: Connecticut River Foundation at Steamboat Dock, 1979.

Storms, Robbi, and Don Malcarne. *Around Essex: Elephants and River Gods.* Charleston, SC: Arcadia Publishing, 2001.

Strother, Horatio T. *The Underground Railroad in Connecticut.* Middletown, CT: Wesleyan University Press, 2011.

Thomas, Betty, dir. *Dr. Dolittle.* 1998.

Trumbull, Benjamin. *A Complete History of Connecticut, Civil and Ecclesiastical, from the Emigration of Its First Planters from England, in the Year 1630, to the Year 1764, and to the Close of the Indian Wars, in Two Volumes.* New Haven, CT: Maltby, Goldsmith and Company, 1818.

Two-Hundredth Anniversary of the First Congregational Church of Haddam, Connecticut, 1700–1900. Haddam, CT: DeVinne Press, 1902.

Van Beynum, William J. *150th Anniversary Commemorative: Portland, Conn.* Portland, CT: 1991.

Van Dusen, Albert E. *Middletown and The American Revolution.* Middletown, CT: Middlesex County Historical Society, 1976.

Wallace, Willard M. *Middletown: 1650–1950.* Middletown, CT: City of Middletown, 1950.

Warner, Elizabeth A. *A Pictorial History of Middletown.* Middletown, CT: Donning Company Publishers, 1990.

Newspapers

Hartford (CT) Courant
Los Angeles Times
Middletown (CT) Press
New Haven (CT) Register
New York Times
Shoreline Times (New Haven, CT)

INDEX

About the Authors

Robert Hubbard is a retired professor at Albertus Magnus College in New Haven, Connecticut. Kathleen Hubbard is a retired teacher from the Middletown, Connecticut public school system. Both were born in Middletown, and each has lived in Middlesex County towns for thirty years. They are the authors of Images of America: *Middletown* and *Legendary Locals of Middletown*. In addition, Robert is the author of *Armchair Reader: The Last Survivors*, Images of America: *Glastonbury, Connecticut's Deadliest Tornadoes* and *Major General Israel Putnam, Hero of the American Revolution*.

Visit us at
www.historypress.com